Contents

Piotr Bienkowski is Curator of Egyptian and Near Eastern Antiquities at the National Museums and Galleries on Merseyside and Honorary Research Fellow in the School of Archaeology, Classics and Oriental Studies at the University of Liverpool. He has carried out fieldwork in the Near East and has published many articles and books on the archaeology of Egypt and the Near East.

Angela Tooley has a PhD in Egyptology from the University of Liverpool. She has worked at the Liverpool Museum and at the Ashmolean Museum, Oxford. She has carried out fieldwork in Amarna in Egypt and has published several articles and a book specialising in Egyptian models.

Acknowledgements

The authors wish to thank Janice Carpenter, Basia Chlebik, Christopher Eyre, Joanna Hayward, Louise Hosking, Joanne Howdle, Joanne Irvine, Amy de Joia, Penelope Nutter, Paul Roberts, Barbara Watterson, Pat Winker and Lucy Wood, as well as Philip Glover, Anne Muffett and Guy Warren from HMSO, for their assistance with the preparation of this book.

The authors and publisher are grateful to the following for permission to reproduce their photographs:

Christopher Eyre, 18; Griffith Institute, Ashmolean Museum, Oxford, 5; Brent Hile, 144; A F Kersting, 15; Lady Lever Art Gallery, 161; Liverpool City Record Office, 158; School of Archaeology, Classics and Oriental Studies, University of Liverpool, 148, 149, 159; University of Liverpool Art Gallery and Collections, 4; Musée de Versailles, 3 (© Photo Réunion des Musées Nationaux); Walker Art Gallery, 2; Derek Welsby, 145; Werner Forman Archive, 23, 101.

Plates 7 and 9 are by Piotr Bienkowski. All other photographs have been provided by the Photography Department of the National Museums and Galleries on Merseyside, and we are very grateful to Clare Bates, David Flower and Ann O'Leary.

Drawings for the book have been provided as follows:

Val Evans, Design Department, National Museums and Galleries on Merseyside, 8; Paul Roberts, chapter headings, 24, 29, 30, 33, 36, glossary illustrations.

Please renew/return this item by the last date shown.

So that your telephone call is charged at local rate,
please call the numbers as set out below:

	From Area codes 01923 or 0208:	From the rest of Herts:
Renewals:	01923 471373	01438 737373
Enquiries:	01923 471333	01438 737333
Minicom:	01923 471599	01438 737599

L32b

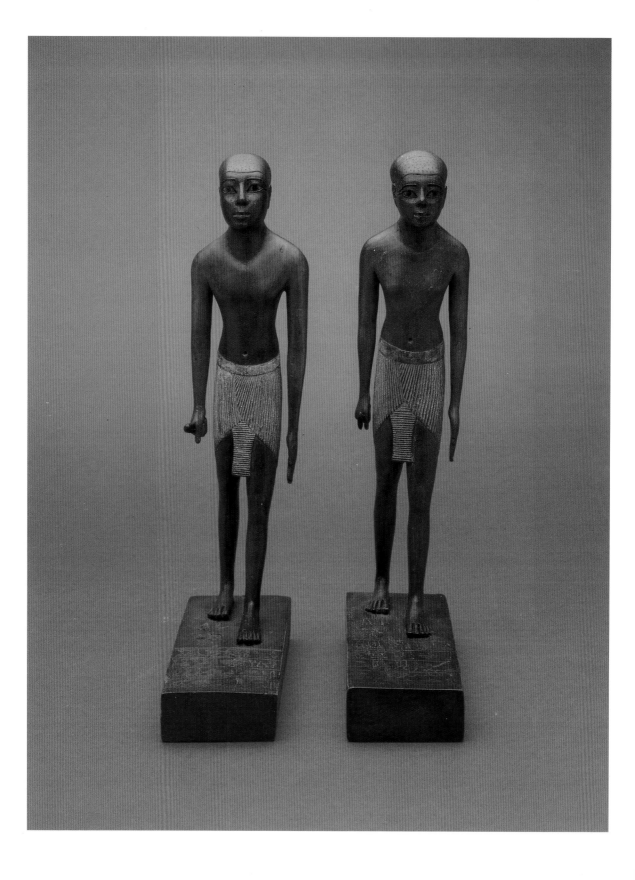

PIOTR BIENKOWSKI AND ANGELA MJ TOOLEY

GIFTS
OF THE
NILE

Ancient Egyptian Arts and Crafts
in Liverpool Museum

NATIONAL MUSEUMS & GALLERIES
· ON MERSEYSIDE ·

London : HMSO

Published by HMSO and available from:

HMSO Publications Centre
(Mail, fax and telephone orders only)
PO Box 276, London SW8 5DT
Telephone orders 0171 873 9090
General enquiries 0171 873 0011
(queuing system in operation for
both numbers)
Fax orders 0171 873 8200

HMSO Bookshops
49 High Holborn, London WC1V 6HB
(counter service only)
0171 873 0011 Fax 0171 831 1326
68–69 Bull Street, Birmingham, B4 6AD
0121 236 9696 Fax 0121 236 9699
33 Wine Street, Bristol BS1 2BQ
0117 926 4306 Fax 0117 929 4515
9–21 Princess Street,
Manchester M60 8AS
0161 834 7201 Fax 0161 833 0634
16 Arthur Street, Belfast BT1 4GD
01232 238451 Fax 01232 235401
71 Lothian Road, Edinburgh EH3 9AZ
0131 228 4181 Fax 0131 229 2734
The HMSO Oriel Bookshop
The Friary, Cardiff CF1 4AA
01222 395548 Fax 01222 384347

HMSO's Accredited Agents
(see Yellow Pages)

and through good booksellers

Applications for reproduction should be made to HMSO Copyright Unit
ISBN 0 11 290538 2

British Library Cataloguing in Publication Data
A CIP catalogue record for this book is available from the British Library

Printed in the United Kingdom for HMSO
Dd 297425 C85 6/95 3396/2 20249

The Egyptian hieroglyphs used as chapter headings, next to page
numbers and on the back cover are determinatives (see chapter 4) used in
words for man and his occupations:

Back cover: 'official', holding stick and handkerchief.
Page numbers: 'adore', with arms raised.
Chapter 1: 'drive away', threatening with stick.
Chapter 2: 'pound or build', pounding in a mortar.
Chapter 3: 'strike', striking with stick.
Chapter 4: 'praise', with arms outstretched.
Chapter 5: 'statue', with stick and sceptre.
Chapter 6: 'build', building a wall.
Chapter 7: 'old', bent man leaning on stick.
Chapter 8: 'wander', with stick and bundle on shoulder.

Frontispiece: see plate 48, page 39

1
The Legacy of Egypt and the Development of Egyptology

Boris Karloff as 'The Mummy' or Elizabeth Taylor as Cleopatra may seem to us the most visible legacy of the pharaohs. The modern world, however, owes much of real value to ancient Egypt. It was the Egyptians who first divided the day into 24 hours, and the year into 365 days. Egyptian hieroglyphs were almost certainly a model for the alphabet, which was invented in Palestine and came to us through the Greeks and Romans. Names such as 'Susan', and words like 'ebony', 'gum' and 'sack' are Egyptian in origin.

Many Egyptian ideas came to us through the Greeks, Romans and early Christianity, while the land of the pharaohs itself was forgotten. By the end of the 4th century AD, ancient Egyptian culture had been eclipsed by the influence of Greek thought. Greek and Roman writers had no proper understanding of Egyptian culture. They could not read Egyptian hieroglyphs, which were essentially phonetic, but interpreted them as allegorical. Egypt was regarded as a repository of esoteric wisdom. The appeal of things Egyptian was linked to the worship of the gods Isis and Serapis, whose cults spread all over the Mediterranean and were established at Rome by the 1st century BC. Egyptian art was widely imitated, but with no real understanding of its character. The Emperor Hadrian's villa at Tivoli was filled with real and imitation Egyptian objects. Obelisks were brought from Egypt to Rome by emperors from Augustus on, and many had fake hieroglyphic inscriptions carved by local Roman craftsmen (plates 1–2).

1 *These statues were found in Rome and purchased in 1777 and 1802 by Henry Blundell of Ince Blundell Hall in Lancashire as part of his collection of nearly 600 classical sculptures. The red granite figure of a man may well have been carved in Egypt. There were several similar statues in the Capitol at Rome in the 18th century, and this one was originally in the collection of Lord Mendip. The marble figure of a draped male came from the great collection of the Mattei family in Rome. Originally this statue had none of its 'Egyptian' attributes or the vase, all of which were added during restoration in the 18th century. H: 152 cm, 192 cm. Roman.*

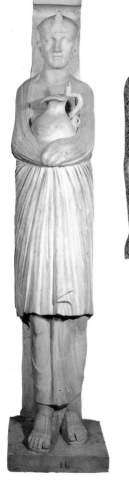

Interest in Eygpt and knowledge of it was revived during the Renaissance. Among the first Classical texts rediscovered in the 15th century was the *Hieroglyphica* of Horapollo, written about the 4th century AD. It maintained that hieroglyphs gave symbolic expression to obscure philosophical and religious doctrines. This false view became the basis of Renaissance Egyptology, and was virtually unchallenged for the next four centuries.

The first European visitors to Egypt arrived during the late 16th and early 17th centuries. The purpose of their visits was to collect objects, mostly in the form of mummies and Coptic papyri. These manuscripts, written in the Greek script, were to be influential in the decipherment of the ancient Egyptian language to which Coptic is related. During the late 1700s and after, numbers of fake Egyptian objects were produced, many finding their way into collections.

In 1798 Napoleon Bonaparte (plate 3) led a military expedition to Egypt with the purpose of dominating the eastern Mediterranean and directly threatening British power in India. His campaign was accompanied by a team of 150 scholars who studied and recorded all aspects of Egypt. Egyptology as we know it was a product of this expedition, with the accidental unearthing of the Rosetta Stone and the subsequent decipherment of hieroglyphs in 1822 by Jean François Champollion (1790–1832). After Napoleon's expedition and the unlocking of the hitherto misunderstood language, general interest in things Egyptian became more widespread. For several decades the 'Egyptian style' was immensely popular in Europe in painting, decorative arts, furniture and architecture.

Muhammad Ali, who took over the government of Egypt in 1805, opened up the country to European travellers. Consuls of European powers were especially prominent in amassing collections of Egyptian antiquities, but their manner of collecting destroyed as much as it recovered. The principal agent of Henry Salt, the British Consul-General, was Giovanni Battista Belzoni (1778–1823), a former Capuchin monk and theatre strong man.

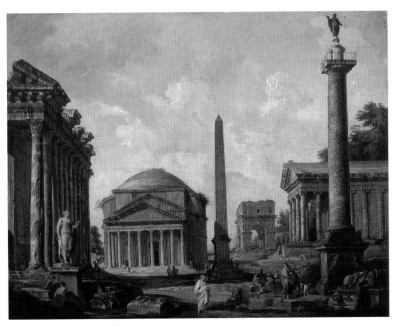

2 Ruins of Rome, *by Giovanni Paolo Panini (1691/2–1765), probably painted in 1741. This is not an actual view, but a rearrangement of some of the most famous buildings of ancient Rome. The obelisk, inscribed with the cartouches of Seti I and Ramesses II, was brought from Heliopolis to Rome by the first emperor, Augustus, after his victory at Actium over Antony and Cleopatra in 31 BC. It was originally placed in the Circus Maximus, and re-erected in the Piazza del Popolo in 1589 by Pope Sixtus V.*

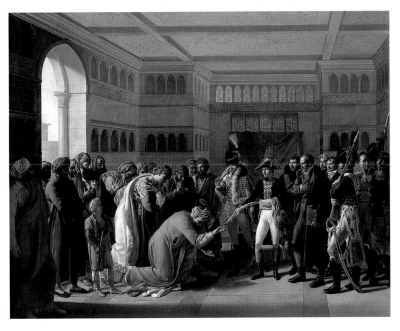

3 General Bonaparte gives a sabre to the military commander of Alexandria, July 1798, *by François Henri Mulard (1769–1850), probably painted in 1807–8. This painting was commissioned by Napoleon for the throne room of the Tuileries palace. It was Napoleon's interest in Egypt, which resulted in Britain's involvement for strategic reasons, that really opened up the country to western visitors for the first time and was largely responsible for the development of Egyptology.*

He specialised in moving heavy antiquities down the Nile to Alexandria for shipping to England, but was responsible for considerable damage when entering tombs to search for funerary papyri. However, he made several important discoveries and published accounts of his work, and was later praised for his achievements by Howard Carter, discoverer of the tomb of Tutankhamun. Belzoni died of dysentery *en route* for Timbuktu while on an expedition to trace the source of the river Niger.

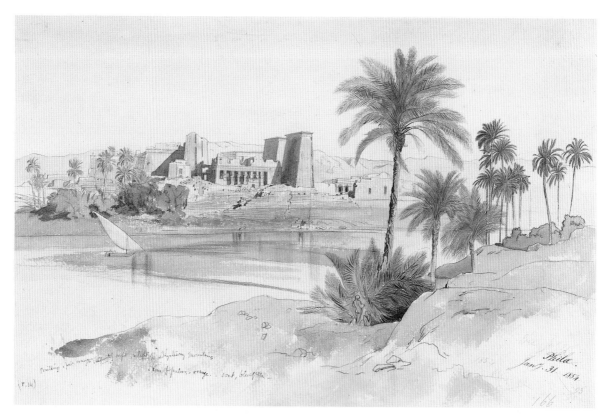

4 Philae, January 31, 1854, *by Edward Lear (1812–1888). This watercolour shows the island and the temple of Philae from the river bank. Lear is best known for his nonsense verses for children, but he was also a landscape painter and visited Egypt five times. He recalled his impressions in his poem 'The Pelican Chorus': 'We live on the Nile. The Nile we love By night we sleep on the cliffs above'.*

Work in Egypt was first properly organised by Auguste Mariette (1821–1881), who founded the Egyptian museum at Boulak and the Egyptian Antiquities Service in 1858. The Egypt Exploration Fund (EEF) in England was founded in 1883 by a small group of scholars and interested amateurs, who were concerned by the neglect and destruction of monuments in Egypt, and the lack of properly organised excavations (the name was changed to Egypt Exploration Society in 1919). The EEF was the first British institution to undertake regular excavations. One of their principal excavators was William Matthew Flinders Petrie (1853–1942).

Petrie was the true pioneer of scientific archaeology. He excavated at sites all over Egypt, publishing a volume on his results almost every year. He realised that the history of Egypt was to be read in the potsherds, bricks, beads and flints which littered every settlement site and cemetery. His work, based on the principles of accurate observation and precise recording, provided the first reliable framework for Egyptian archaeology. Petrie excavated for the EEF from 1883 to 1886, but then quarrelled with them and severed his connections for a few years. He began to excavate separately, eventually acquiring funding from the Egyptian Research

Account, which he founded in 1894 and later enlarged into the British School of Archaeology in Egypt. In 1892 Petrie was appointed the first Professor of Egyptology in England at University College London, a post he held for 41 years.

Among the many young Egyptologists who learned their techniques from Petrie was Howard Carter (1874–1939) (plate 5). Carter was originally employed as an accomplished draughtsman and painter. His greatest contribution in his early years of working for the EEF was the recording of the mortuary temple of Queen Hatshepsut at Deir el-Bahri between 1893 and 1898. By making full-scale tracings of the reliefs and inscriptions against a wall, then redrawing them by means of a grid and producing finished drawings in pencil or crayon, constantly checking against the originals, Carter and his team produced a facsimile record of thousands of metres of decorated wall surface, which was published in six volumes.

Carter was appointed to the Egyptian Antiquities Service in 1899, resigning in 1903 because of a dispute with French tourists at Saqqara. He painted watercolours to sell to tourists for the next four years, before beginning work at Thebes in 1907 on behalf of Lord Carnarvon. Carter in fact discovered six royal tombs during his career, but it was the discovery of the tomb of Tutankhamun in 1922, after three years of searching, that was one of the greatest finds in Egyptology. The clearance of the tomb and the packing and removal of objects took 10 years to complete. Work on the final cataloguing and publication of the objects is still continuing.

5 *Howard Carter gently brushes away the decayed remains of the linen shroud which covered the face of the second coffin of Tutankhamun. The boy-king had three coffins, the third, innermost one containing his mummy with its gold mask. The appearance of the second, middle coffin is different from the others and it may originally have been made for someone else, as with other objects found in the tomb.*

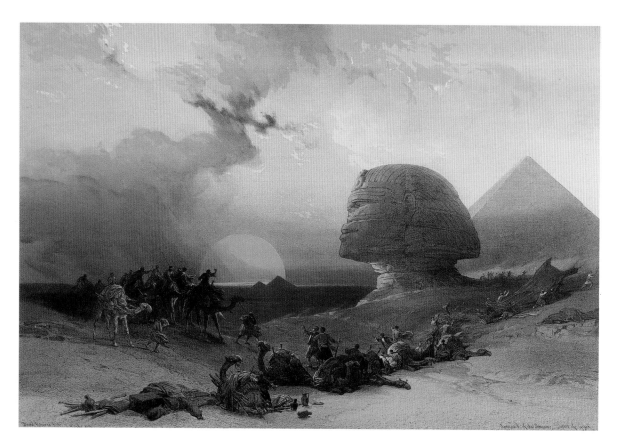

6 Approach of the Simoom – Desert of Gizeh, *from* Egypt and Nubia *Volume III (1849) by David Roberts (1796–1864). Roberts was arguably the best and most productive of all the artists working on Egyptian subjects in the mid-19th century. Normally he recorded with great accuracy, but in this picture of an imminent sandstorm he was carried away by his composition and placed the sphinx, pyramid and sun incorrectly. Roberts presented the original painting, from which this lithograph was made, to Charles Dickens, who called it 'a poetic conception'.*

A comparable find, though much less well known, was made by the French Egyptologist Pierre Montet (1885–1966), who in 1939 discovered a group of six royal tombs at Tanis in the Delta. Three of the tombs contained the rich burials of the kings Psussenes I, Osorkon II and Sheshonk III of the 21st and 22nd Dynasties – the greatest number of unplundered royal burials ever discovered in Egypt. But the world was preoccupied with the approaching war and the discovery received little public attention.

The discovery of the tomb of Tutankhamun led to an explosion of public interest in Egyptology which has never abated. It should be remembered that Tutankhamun was a young, minor king buried in a small, four-room tomb. The tomb's uniqueness was that it was largely intact, except for some minor robbery in antiquity. It is beyond imagination what wonders have been lost through the robbing of the vast tombs of great kings such as Amenophis III and Ramesses II, although many individual objects from their burials have found their way into museum collections.

2
The Land of Egypt

The river Nile is the single most important factor in Egypt. Rainfall in the country is negligible, and agriculture would be impossible without the river. In essence, Egypt is really the cultivated part of the Nile valley.

In antiquity, Egypt stretched from the Mediterranean Sea in the north to the First Cataract at Aswan in the south, about 1,200 kilometres along the river. Just north of Cairo the Nile divides and forms the Delta, in ancient times formed of three principal branches. The amount of fertile land available in the Delta (Lower Egypt) was double that in the Nile valley (Upper Egypt), where the width of arable land varied between 1.5 and 39 kilometres. The Delta became dominant in political and economic life through its agricultural strength.

To east and west, Egypt is bounded by deserts. The Faiyum, a fertile depression in the western desert fed by a side stream of the Nile, terminated in antiquity in Lake Moeris. It was a focus for settlement from about 7000 BC, and of intensive agriculture later.

7 The Nile and the mountains of western Thebes seen from Luxor on the east bank. The river was the principal highway of ancient Egypt from earliest times, since most travel on land was on foot or by donkey at least until the New Kingdom.

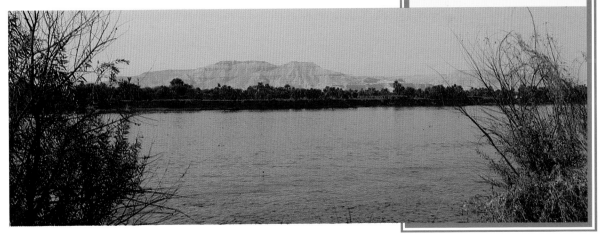

8 *Map of Egypt and Nubia from the Predynastic Period in Egypt to the Islamic Period in Nubia (c.5500 BC–AD 1323).*

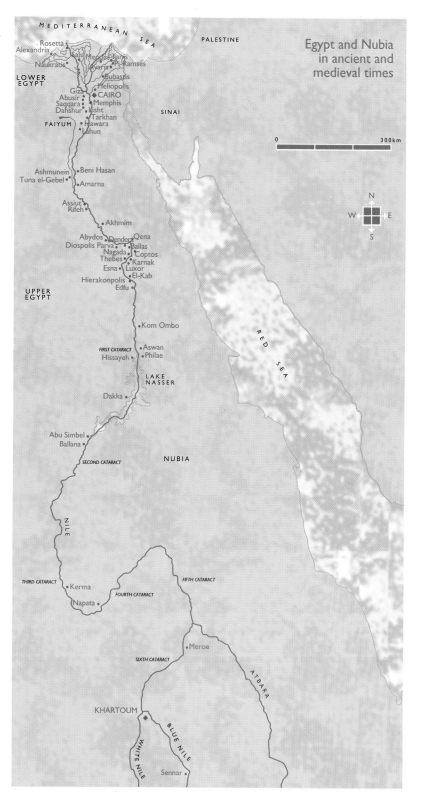

Egypt and Nubia
in ancient and
medieval times

MEDITERRANEAN SEA

PALESTINE

Rosetta
Alexandria
Naukratis
Sais · Mendes · Tanis
· Avaris
Pi-Ramses

LOWER
EGYPT

· Bubastis
· Heliopolis
Giza ·
Abusir · ◆CAIRO
Saqqara · · Memphis
Dahshur · · Kisht
· Tarkhan
FAIYUM · · Hawara
· Lahun

SINAI

0 300km

N
W E
S

Ashmunein · · Beni Hasan
Tuna el-Gebel · · Amarna

Assiut ·
Rifeh ·

· Akhmim

Abydos · · Dendera · Qena
Diospolis Parva · · Ballas
Nagada · · Coptos
Thebes · · Karnak
Esna · · Luxor
Hierakonpolis · · El-Kab
Edfu ·

UPPER
EGYPT

· Kom Ombo

FIRST CATARACT · Aswan
Hissayeh · · Philae

LAKE
NASSER

Dakka ·

Abu Simbel ·
Ballana ·

SECOND CATARACT

NUBIA

RED SEA

NILE

THIRD CATARACT · Kerma
Napata ·
FOURTH CATARACT

FIFTH CATARACT

· Meroe
SIXTH CATARACT

ATBARA

KHARTOUM
◆

WHITE NILE BLUE NILE

· Sennar

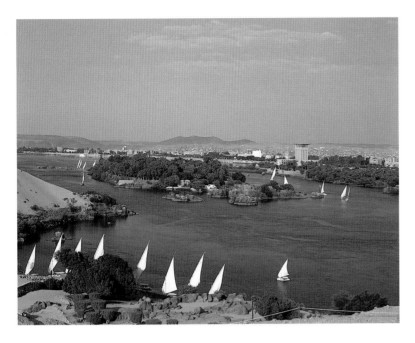

9　*Boats* (feluccas) *on the Nile at Aswan. In ancient times Aswan was the southernmost town of Egypt proper, because the First Cataract made navigation beyond Aswan difficult.*

The oases of the western desert produced valuable crops, and minerals such as natron. The oases were an outpost against marauding Libyans. The Sinai peninsula to the north-east was an important source of turquoise and copper, and the eastern deserts provided building materials and semi-precious stones. The contrast between the rich earth of the valley and the arid surrounding desert is seen in the Egyptians' names for their country, *Kemet* (the Black), as opposed to *Deshret* (the Red). The name Egypt, from the Greek *Aigyptos*, probably derives from an Egyptian name for Memphis, capital during the Old Kingdom, *Hikuptah* (Home of the Spirit of Ptah).

Egypt was surprisingly rich in resources. It could support its own population and build up stocks against famine or to trade. Bread and beer formed the staple diet made from wheat and barley. In Egypt the Nile provided water and fertiliser. It also provided the mud with which to make bricks. The eastern desert provided all Egypt's stone and most of its mineral requirements.

The countries surrounding Egypt were at times under its direct control. To the south, Nubia was the objective of many expeditions for gold and hard stones, and the route through which came many prized African products. Egypt also traded with the countries of the Near East from earliest times. The forests of Lebanon in particular were an important source of good quality wood.

9　

10 *Two boats carrying a single huge cargo of straw in about 1896. In ancient times, heavy and bulky loads such as building materials and monumental sculptures could be transported in flat-bottomed barges directly from quarries to temples and cemeteries, especially during the time of year when the inundation covered most of the cultivated land.*

11 *(Below) painted wooden model from Beni Hasan. The painted bows and stern of this boat imitate the type of craft used by fishermen in the marshes, which would have been made of bound papyrus bundles. The small open-topped canopy sheltered the owner from the sun. Such a canopy is unique to this model. The pilot stands in the bows, his arm outstretched; one man sits behind the steering oar; two men are busy with punt poles; three other crew members raise the sail. L: 104 cm. First Intermediate Period.*

12 *(Right) tomb painting depicting a boat towing another vessel, copied by Norman de Garis Davies (1865–1941), one of the best copyists of ancient Egyptian tombs, who reproduced colours as exactly as possible. This represents the pilgrimage to Abydos, the cult centre of Osiris, which every Egyptian hoped to perform during life or in the afterlife. From the tomb of Pere, Thebes, 18th Dynasty, reign of Tuthmosis IV(?).*

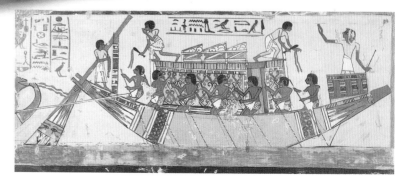

10

The cultivated area in ancient times was determined by the height to which the Nile rose during its annual flooding or inundation. The inundation was at the centre of the Egyptian year, and many religious rituals were concerned with it. The Nile was at its lowest between April and June. As the rains fell and the snow melted in central Africa, the river rose about 8 metres. Originally, the cultivable area was defined by what was covered by the inundation and its rich black silt which gave fertility to the land. From fairly early in Egyptian history, though, the inundation was controlled by a series of canals across fields, so we should not imagine that the whole of the Nile valley was completely flooded to the edge of the desert by each September. The pattern of the inundation can no longer be observed, as the river has been controlled by dams and sluices since the mid-19th century. The modern High Dam at Aswan, completed in 1970, provides irrigation all year round, as well as water for domestic and industrial purposes and for hydroelectric power.

13 *(Below left) shadufs being used in the Nile in the late 19th century. The shaduf is a water-lifting device with a bucket on one end of a pole and a weight on the other. Shadufs are depicted on New Kingdom tomb paintings irrigating gardens, groves and orchards, and can still be seen on the banks of the Nile today. Photographed by Antonio Beato (d. 1903), an Italian who lived in Luxor from 1862 until his death and took a large series of views of the principal temples and monuments in Egypt in the 1860s to 1880s.*

14 *(Below) painted wooden model of a granary, from a tomb at Deir el-Bahri in Thebes, depicting three workmen and three bins for grain. The heads of two scribes recording the grain are visible over the wall. Models like this depict the type of granary found on large estates. Egypt was self-sufficient in all its food needs, but the success of the harvest depended on the inundation. Every estate and house had its own grain storage facility. L: 30 cm. 11th Dynasty.*

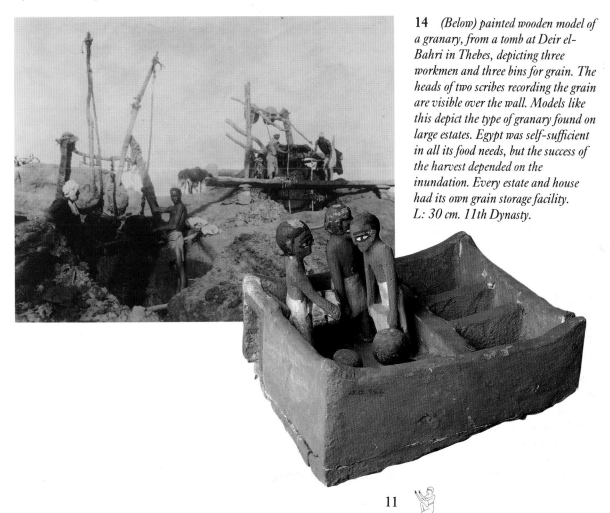

Our evidence for ancient Egyptian civilisation appears biased towards death and religion, with less known of everyday life. Most towns and villages were built of unbaked mud brick, and were situated in the Nile valley on hills. Over the centuries, the brick has crumbled away, and little now remains of ordinary houses. By contrast, temples were built of stone, and despite damage many of these are still standing. Most tombs were in the desert, not in the cultivated valley. They were usually built of stone, or cut into the rock, and so can be extremely well preserved. Often the colourful paintings inside have survived, which show scenes of daily life and religious ritual.

It is this imbalance of evidence which can give the impression that the ancient Egyptians were largely concerned with death and religion. The truth, however, is that all the elaborate preparations for death, such as the pyramids, mummies, painted scenes and inscriptions, were but a means to an end. The Egyptians believed that in this way they could recreate, in the life after death, the best of life on earth. Far from being obsessed with death, they were passionately devoted to life and to the good things available in the land of Egypt.

15 *The flood plain of the river Nile is very flat and fertile, and in antiquity was up to 39 kilometres wide. In the distance can be seen the line at which the cultivation ends and the desert begins, with the Old Kingdom pyramids of Dahshur beyond.*

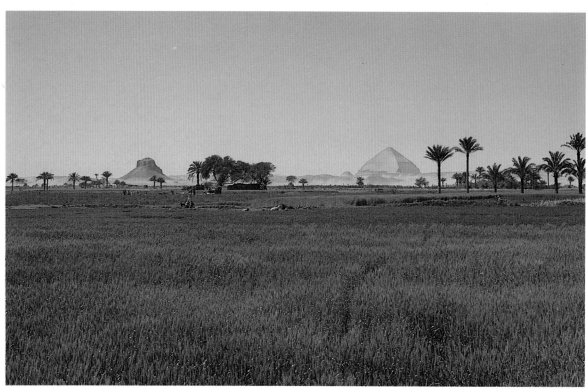

Food and Drink

Bread and beer made from wheat and barley was every Egyptian's staple diet. Painted scenes on tomb walls and the preserved remains of offerings tell us that the Egyptians enjoyed a varied diet of fruit and vegetables: pomegranates, figs, dates, melons, onions, leeks, radishes, beans, lettuces and lentils.

Products of the bakery included various types of bread, cake and biscuit made from emmer wheat and flavoured with honey and fruits. Barley bread tended to be reserved for ritual offerings at temples and in tombs, but was the basis for a type of thick and cloudy beer made from strained bread mixed with water and malted barley.

Protein came from the plentiful fish caught in the Nile and its marshes, as well as ducks, geese and pigeons either especially bred for the table or caught in clap nets and with a type of boomerang. It is known that farm animals included sheep and pigs, but beef in the form of oxen and cattle was enjoyed only by a privileged few. Cattle were kept largely for their dairy produce whilst oxen were draught animals.

Bees were kept for their honey, used to flavour a variety of foods. Other flavourings like pomegranate juice were added to wine. The types of wine produced were white, red and rosé, the best coming from vineyards in the Delta.

Imported pottery containers attest to foodstuffs imported from countries such as Crete and Palestine. Among the products which they contained were cheese, wine and olive oil.

16 *A market place at Ghezirah in the late 19th century. Markets in ancient Egyptian looked very similar, and were placed on street corners or close to harbours where there was a dense population. Tomb scenes show sellers crying out to attract passers-by, and haggling with buyers over prices.*

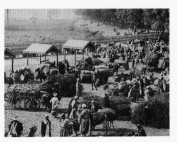

17 *(Bottom) painted wooden model from Beni Hasan showing baking, butchery and brewing. On the left, two women are grinding flour, with a bread oven next to them. In the centre, a man is cutting the throat of an ox with a flint knife; the legs of the ox are tied together, and the butcher kneels with one hand pressing the head to the floor. On the right, another man is pressing barley bread through a sieve into a vat where it will ferment when mixed with water, and perhaps date juice, to make beer. Beside him are other vats and sealed beer jars, two with network coverings. Models like this, showing meat, are from the tombs of the nobles, who were the only Egyptians to eat meat regularly. L: 68.8 cm. Middle Kingdom.*

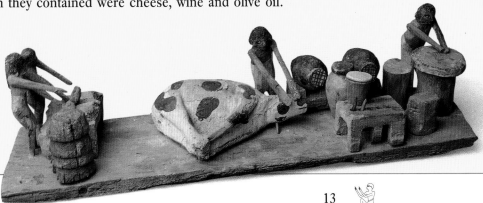

13

Houses and Towns

Domestic housing in ancient Egypt was built almost entirely of mud brick. Bricks were made of Nile silt gathered from the river banks usually after the inundation. Other building materials were reeds, rushes and wood. Stone was used sparingly for lintels, thresholds and column bases.

The typical well-to-do ancient Egyptian house had an entrance room or hall, a pillared reception room leading to bedrooms, and a rear courtyard that was also the kitchen and could contain several small storerooms.

Surviving houses at Amarna and Deir el-Medina are rather small, opening off narrow streets and providing living space for livestock at the front. People sat or slept on low benches built around the walls. Stairs sometimes led to a flat roof used to store food and for sleeping during hot weather. In these small houses people cooked on circular hearths in the main room, and in winter these provided much-needed heat. Large and luxurious villas found at Amarna included living quarters for household servants within their enclosure walls.

The oldest towns do not appear to have been planned, but radiated outwards from a central square, temple or crossroads. They were surrounded by a circular girdle wall several metres tall and thick which probably formed a type of defence during times of unrest. Some towns were planned and were laid out regularly within linear enclosure walls. These settlements, especially those built for pyramid and tomb builders, contained rows of virtually identical houses along straight sections of wall or roads, with larger houses built for the overseers.

18 *A modern village by the Nile. As in ancient times, many of the houses are built of mud brick.*

3
A Brief History of Ancient Egypt

Chronology

The chronological system we use for ancient Egypt is based on the division of kings into 30 dynasties by Manetho, a priest who wrote a history of Egypt in the 3rd century BC. His original work has not survived, but parts are preserved by the later historians Josephus, Africanus and Eusebius. Manetho wrote in Greek, and used a Greek form for the names of the Egyptian kings. This better-known Greek form is used throughout this book: for example Cheops (Egyptian Khufu), Chephren (Egyptian Khafre), Mycerinus (Egyptian Menkaure), Amenemmes (Egyptian Amenemhat), Sesostris (Egyptian Senwosret), Tuthmosis (Egyptian Thutmose), Amenophis (Egyptian Amenhotep). Little survives of the ancient Egyptian sources that Manetho must have used. In modern times a further dynasty has been added to the original 30, Dynasty 31 being the second period of Persian rule over Egypt.

The ancient Egyptians had no single, continuous era for counting years, such as our modern use of years BC and AD. Instead, they dated documents and events by the year of a king's reign. It is difficult to place Egyptian kings in the right order and to give them a precise date BC. We do not know the exact length of the reigns of some kings. The ancient texts also do not indicate when kings ruled simultaneously in different parts of Egypt. Ancient lists of kings sometimes give their supposed lengths of reign, but no single text gives a complete series of all the kings, and there are many gaps. Egyptian records of astronomical observations were often dated by the year of a king's reign. We can try to calculate when these astronomical events took place, and work out the absolute date on our own calendar. There are many uncertainties, however, and there is usually more than one possible absolute date BC for any ancient Egyptian date.

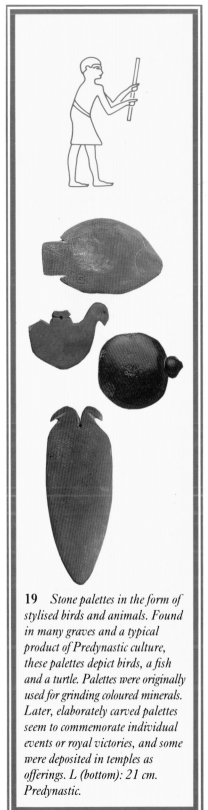

19 *Stone palettes in the form of stylised birds and animals. Found in many graves and a typical product of Predynastic culture, these palettes depict birds, a fish and a turtle. Palettes were originally used for grinding coloured minerals. Later, elaborately carved palettes seem to commemorate individual events or royal victories, and some were deposited in temples as offerings. L (bottom): 21 cm. Predynastic.*

15

20 (Above) flint tools from Abydos and Nagada. In Predynastic times the technique of making pressure-flaked stone tools achieved an amazing degree of perfection. L (left): 20.5 cm. Predynastic to Early Dynastic.

21 (Below) stone of many kinds was used for the dishes, bowls and jars found in large numbers in early graves. Egyptian alabaster was a favourite material because of its translucency and beautiful markings. The interiors were hollowed using a bow drill with a copper or stone bit and abrasive sand. The outsides were shaped with stone tools and polished. The skill of the stone-cutter is exemplified by the eggshell thinness of some vessels. H (left): 12 cm. Predynastic.

Table of Egyptian chronology

Period	Date	Dynasties and sub-periods
Predynastic Period	5500–4000 BC	Badarian
	4000–3500 BC	Amratian (Nagada I)
	3500–3100 BC	Gerzean (Nagada II–III)
Early Dynastic Period	3100–2686 BC	Dynasties 1–2
Old Kingdom	2686–2181 BC	Dynasties 3–6
First Intermediate Period	2181–2040 BC	Dynasties 7–10
Middle Kingdom	2133–1786 BC	Dynasties 11–12
Second Intermediate Period	1786–1567 BC	Dynasties 13–17
New Kingdom	1567–1085 BC	Dynasties 18–20
Third Intermediate Period	1085–664 BC	Dynasties 21–25
Late Dynastic Period	664–332 BC	Dynasties 26–31
Ptolemaic Period	332–30 BC	
Roman Period	30 BC–AD 395	
Byzantine empire	AD 395–AD 640	
Arab conquest	AD 640	

Predynastic Period

The earliest traces of human occupation in the Nile valley are in the Palaeolithic period about 250,000 BC, although there is evidence of earlier occupation in the western desert. At this time, man was living the life of a nomad and hunter all over north Africa, and his most common tool was a stone hand axe. The earliest settled, food-producing cultures of the Neolithic – the Tasian, Badarian and Nagada I (or Amratian) – were fairly localised and consisted of small-scale villages.

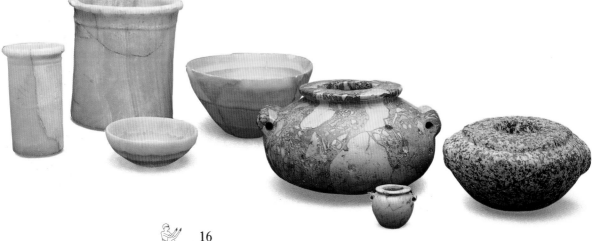

The Nagada II (or Gerzean) culture (*c.*3500 BC) was a turning-point. It covered the entire Nile valley, with large population centres at Hierakonpolis, Coptos, Nagada and Abydos. Craftsmen developed technical skills, especially in the manufacture of hard stone vessels (plates 19–21). This was the first culture to have significant contacts with other countries, probably through trade. Motifs in art and perhaps the idea of writing came from Mesopotamia (modern Iraq).

Later written sources imply that at this time there were rulers of two lands, Upper and Lower Egypt. A cemetery at Abydos may contain Predynastic royal tombs, near the later tombs of the 1st-Dynasty kings.

Early Dynastic (Archaic) Period
(Dynasties 1–2, *c.*3100–2686 BC)

The 1st Dynasty begins with the legendary King Menes. In later tradition, he was credited with the conquest of the north, which led to the unification of the two kingdoms of Upper and Lower Egypt. No contemporary monument can be claimed as his, but he is generally identified with King Narmer and may embody a group of kings who tried to unite the country. Menes may be a composite of several kings whose names are now lost.

Two main changes mark the beginning of the 1st Dynasty: the spread of writing, and the founding of Memphis, possibly the capital from then on. We have little knowledge of historical events. There is some evidence for military expeditions to Sinai, and perhaps of political upheavals during the 2nd Dynasty.

22 *Copper models from the tomb of King Khasekemwi at Abydos. Many copper objects were found in the tomb of this last king of the 2nd Dynasty. Most were made to be buried as offerings and were not intended for practical use. They include harpoon heads and knives roughly stamped from copper sheets, needles, and small bowls pressed out of shape by the weight of other objects. D (left): 20 cm. Early Dynastic.*

23 *The Great Pyramid of Cheops at Giza, seen from behind the pyramid of Chephren, both 4th Dynasty. The core of these pyramids was constructed from stone blocks which are now exposed. The fine casing which originally covered the pyramids is still preserved at the summit of the pyramid of Chephren and on part of its base. It is estimated that at least 2,300,000 stone blocks averaging 2.5 tonnes were used in the Great Pyramid's construction, which was the work of skilled craftsmen, not untrained slaves as is often thought. Pyramids were a part of larger complexes, including a mortuary temple where the funerary cult of the dead king was practised, and the valley temple in which the final rites were performed on the body.*

Old Kingdom
(Dynasties 3–6, c.2686–2181 BC)

The Old Kingdom, sometimes called the Pyramid Age, is best known for its architecture, sculpture and monumental tomb reliefs. The major achievement of the 3rd Dynasty was the Step Pyramid of King Zoser (c.2650 BC). This is the oldest stone building of its size in the world.

The 4th Dynasty (c.2613–2494 BC) is the time of the great pyramids. The pyramids at Giza of Cheops, Chephren and Mycerinus are the most famous (plates 23, 24, 137). The true pyramid (as opposed to the stepped form) was probably a solar symbol, and the cult of the sun-god Re was prominent. Each pyramid was surrounded by the mastaba ('bench-shaped') tombs of the king's family and nobles, reflecting royal authority. The Egyptians campaigned extensively in Libya, Nubia and Palestine in this period, to protect their frontiers and to ensure the supply of

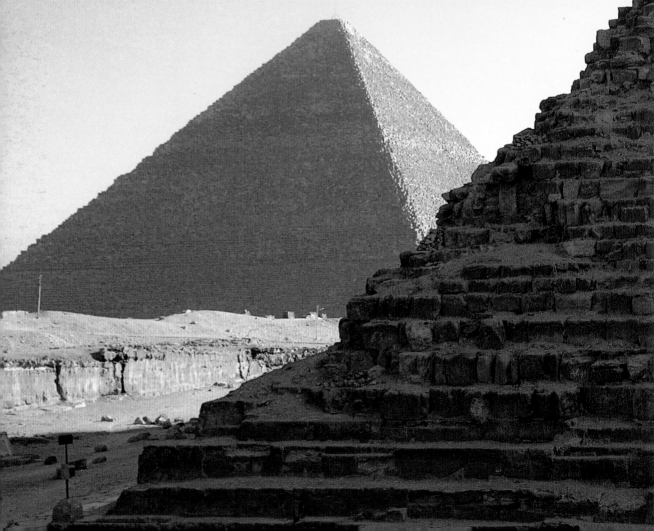

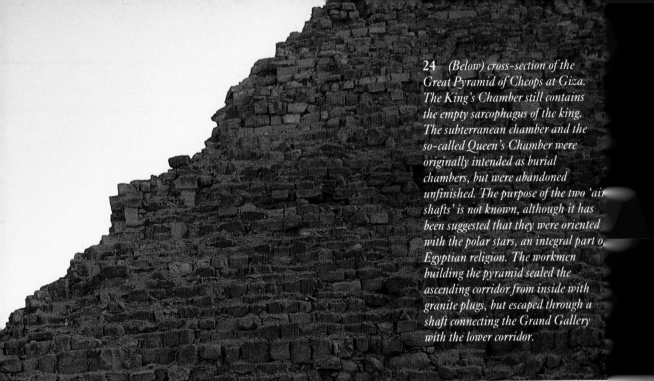

24 *(Below) cross-section of the Great Pyramid of Cheops at Giza. The King's Chamber still contains the empty sarcophagus of the king. The subterranean chamber and the so-called Queen's Chamber were originally intended as burial chambers, but were abandoned unfinished. The purpose of the two 'air shafts' is not known, although it has been suggested that they were oriented with the polar stars, an integral part of Egyptian religion. The workmen building the pyramid sealed the ascending corridor from inside with granite plugs, but escaped through a shaft connecting the Grand Gallery with the lower corridor.*

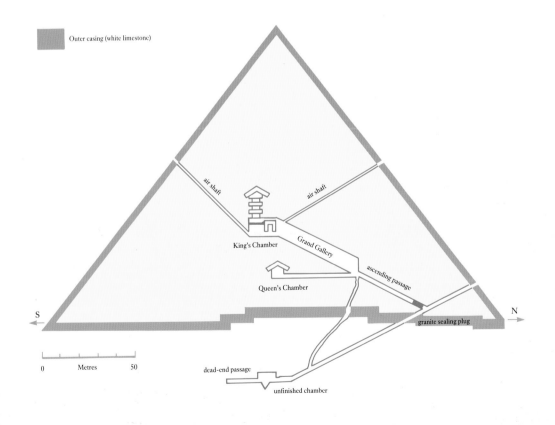

Outer casing (white limestone)

air shaft

air shaft

King's Chamber

Grand Gallery

ascending passage

Queen's Chamber

S

N

granite sealing plug

0 Metres 50

dead-end passage

unfinished chamber

raw materials and exotic products not found within the Nile valley. An Egyptian temple was built at Byblos in Lebanon, a vital source of wood.

By the 5th Dynasty (*c.*2494–2345 BC), the size of pyramids was much reduced, probably as a result of economic decline. Famine may have been a factor, caused by a series of low inundations. The king's authority lessened, and the power of provincial officials increased. These nobles became hereditary holders of their posts, and treated their regions as personal property. Central authority finally collapsed after the 94-year reign of Pepy II of the 6th Dynasty (*c.*2345–2181 BC).

First Intermediate Period (Dynasties 7–10, *c.*2181–2040 BC)

The period of chaos following the collapse of the Old Kingdom is known as the First Intermediate Period. During this time there was a succession of ephemeral kings and a splitting of the country into the two kingdoms of Upper and Lower Egypt with their own kinglets.

Middle Kingdom (Dynasties 11–12, *c.*2133–1786 BC)

Eventually, the Theban king Nebhepetre Mentuhotep II of the 11th Dynasty (*c.*2133–1991 BC) reunited the country in 2040 BC. The first king of the 12th Dynasty, Amenemmes I (*c.*1991–1962 BC), moved his capital from Thebes to Itj-tawy near Memphis. Kings were buried in pyramids at Lisht, Dahshur, Lahun and Hawara. Sesostris III (*c.*1878–1843 BC) reformed the administration and removed power from the provincial nobles. The 12th Dynasty gained control of Nubia, where it set up a series of forts. There was extensive trade with Palestine and Syria, although a fortification known as the 'Walls of the Prince' was erected to protect the Delta from infiltrating Asiatics.

The Middle Kingdom was the golden age of Egyptian language, literature, arts and crafts. Many stories and myths were first composed at this time, and were copied as school exercises for centuries to come. Middle Kingdom art, in its quality of design and execution, is probably the finest of any period.

20

Second Intermediate Period
(Dynasties 13–17, c.1786–1567 BC)

As the authority of the 13th Dynasty (c.1786–1633 BC) gradually disintegrated, a line of Asiatic rulers established itself at Avaris in the Delta. This is the 15th Dynasty (c.1674–1567 BC), known as the 'Hyksos' from an Egyptian phrase meaning 'rulers of foreign lands'. They seem to have been recognised as kings over the whole country, but tolerated the existence of other minor dynasties. The Hyksos were regarded as cruel invaders by later tradition, but they introduced important innovations from the Near East, such as improved bronzeworking, the light horse-drawn chariot and the composite bow. Contemporary with the Hyksos were minor kings of city states, who probably make up Manetho's obscure 16th Dynasty.

Hyksos rule was eventually challenged by the 17th Dynasty (c.1650–1567 BC), a line of native Egyptians ruling in Thebes. Kamose, last ruler of the 17th Dynasty, campaigned against the Hyksos and their Nubian allies. His successor Ahmose (c.1570–1546 BC), founder of the 18th Dynasty, captured Avaris and expelled the Hyksos from Egypt.

New Kingdom
(Dynasties 18–20, c.1567–1085 BC)

The New Kingdom was a period of prosperity, when Egypt ruled much of the ancient Near East. The 18th-Dynasty kings conquered a huge territory stretching from the Fourth Cataract of the Nile in Sudan to the Euphrates in Syria. They were in close diplomatic and commercial contact with the other great powers of Hatti (Anatolia, now modern Turkey), Babylonia (southern Iraq), Assyria (northern Iraq) and Mitanni (northern Syria). The small states in Syria and Palestine became part of the Egyptian empire, under Egyptian governors and with garrisons of Egyptian troops, although the vassal princes were allowed to continue ruling. Nubia was treated as a colony, administered directly by Egyptians under a viceroy.

Amenophis IV (c.1379–1362 BC) of the 18th Dynasty instigated a remarkable religious revolution unparalleled in Egyptian history.

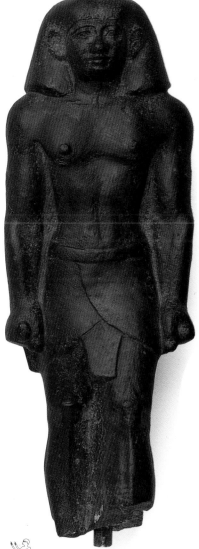

25 *Basalt figure of a striding man. The inscription on the back pillar identifies him as Ankhenmer of Asyut and gives his titles as prince, mayor, royal acquaintance and herald of the king. Ankhenmer was therefore a man of high rank who had access to the king and functioned on his behalf as a reporter of events. The inscription makes clear that the figure was placed in the temple of the wolf god Wepwawet in Asyut, and it asks every priest entering the temple to recite the formula to provide offerings for Ankhenmer. H: 25.5 cm. 13th Dynasty.*

He discarded the worship of Amun-Re and the traditional gods of Egypt in favour of a single god, Aten, a manifestation of the sun-god as the visible sun-disk. He changed his name from Amenophis ('Amun is pleased') to Akhenaten ('beneficial to Aten'). He built a new capital at Amarna, which he called 'Akhetaten' ('the horizon of Aten'). A new style of art developed under his stimulus, characterised by exaggerated forms.

The following reigns attempted to remove systematically all traces of Akhenaten's heresy. Tutankhamun (c.1361–1352 BC) abandoned Amarna and moved the capital to Memphis. Later, Ramesses II (c.1304–1237 BC) moved it again to Pi-Ramses in the Delta, at that time the economic centre of the country.

The giant figure of Ramesses II dominates the 19th Dynasty. He erected more buildings and statues than any other Egyptian king during his 66-year reign. Ramesses was very active militarily, especially against the Hittites in Syria with whom he eventually signed a peace treaty. His successors were faced with a series of invasions by Libyans and groups of foreigners called Sea Peoples. These were finally defeated by Ramesses III (c.1198–1166 BC) of the 20th Dynasty. The prisoners of war were settled in colonies and later became a powerful political force.

After the death of Ramesses III, Egypt was weakened by court intrigues, conspiracies and strikes, and the empire crumbled away. The foreign successes of the New Kingdom kings had benefited the great temple of Amun-Re at Karnak, which was now the richest shrine in the country. Priestly offices became hereditary, and at the end of the 20th Dynasty the country was effectively partitioned between the kings in the Delta and the High Priests of Amun at Thebes.

Third Intermediate Period (Dynasties 21–25, c.1085–664 BC)

The kings of the 21st Dynasty (c.1085–935 BC) ruled from Tanis in the Delta, while southern Egypt was under the Theban High Priests (from 1070 BC). Sheshonk I (c.935–914 BC) of the 22nd Dynasty attempted to centralise Egypt from his capital at Bubastis in the Delta, but his reign was marked by unrest and divided

authority. About 724 BC, Egypt was invaded by Piankhi (or Piye), a Nubian ruler from Napata. The Nubian kings of the 25th Dynasty (c.750–657 BC) reunified Egypt and instigated a cultural and artistic revival. In the early 7th century BC the Assyrians invaded Egypt several times, occupying Memphis and advancing as far as Thebes.

Late Dynastic Period
(Dynasties 26–31, c.664–332 BC)

Psammetichus, a prince of Sais (664–610 BC), expelled the Assyrians, reunited Egypt and inaugurated the 26th (Saite) Dynasty. The Saite period was a century of renewed splendour. Art, religion and administration were inspired by the styles and practices of the Old and Middle Kingdoms.

In 525 BC the Persians, who had overthrown the Babylonian empire, captured the whole of Egypt and ruled as the 27th Dynasty. For the next two hundred years Egypt was intermittently a province of the Persian empire. The Persians reformed the administration, codified laws, commissioned temple building and undertook public works, such as the completion of the canal connecting the Nile with the Red Sea.

With the death of the Persian king Darius II (404 BC) Egypt was freed, and the 28th to 30th Dynasties struggled to maintain its independence. In 343 BC, though, the Persians once more subjugated Egypt, this time more oppressively.

Graeco-Roman Period
(332 BC–AD 395)

Alexander the Great finally ended Persian rule in 332 BC. After his death at Babylon in 323 BC, Alexander was buried first in Memphis and then in Alexandria, the Egyptian city he had founded. At the division of his empire, the general Ptolemy acquired Egypt. He proclaimed himself king as Ptolemy I Soter (304–282 BC), adopted Egyptian royal titles and established the Ptolemaic dynasty.

Greek was the official language of Egypt under the Ptolemies. Greek influence in art, administration and military organisation

26 *Fragment of limestone carved in raised relief, probably from the mortuary temple of Queen Hatshepsut at Deir el-Bahri, Thebes, showing her father and husband Tuthmosis I wearing the long royal beard and a soft wig cover with a coiled uraeus. The sculptor changed his mind about the position of the arms, but when the relief was finished the alteration would have been invisible beneath a coating of plaster and paint.*
H: 36 cm.
18th Dynasty.

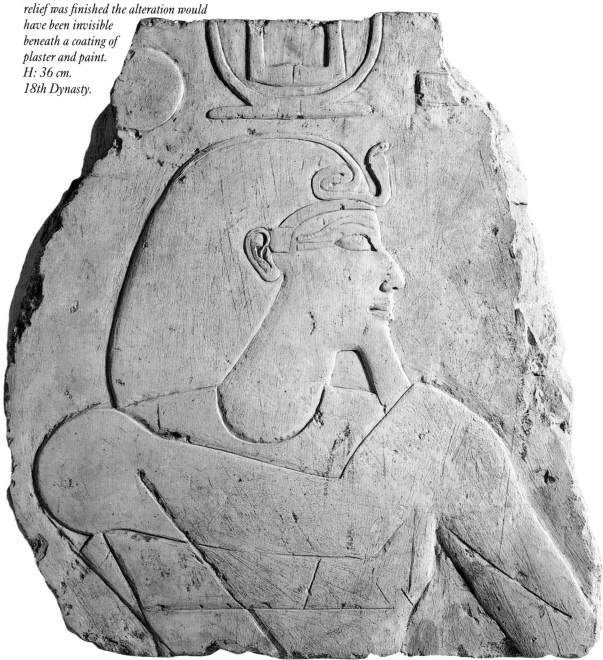

continued for the next 300 years. The traditional gods were still worshipped. New gods were also introduced, such as Serapis, a blend of the Egyptian Osiris and Apis and the Greek Zeus and other gods. Some of the best-preserved temples are Ptolemaic constructions, in particular Edfu, Kom Ombo and Philae. The Ptolemies built new ports, developed trade and encouraged contact with Asia and the Mediterranean. They were great patrons of learning, one of their finest creations being the library of Alexandria, which eventually held half a million papyrus and leather scrolls but was finally destroyed by fire by Christians in AD 391.

Egypt was ruled from Alexandria, in effect an independent state where Egyptians were not really welcome. Greek rule was characterised by dynastic quarrels and internal strife, resulting in a rapid succession of kings and queens named Ptolemy and Cleopatra. The Romans gradually intervened in Ptolemaic affairs, culminating in the battle of Actium in 31 BC between Mark Antony on behalf of Cleopatra VII, and Octavian (later the first emperor, Augustus Caesar).

With the suicide of Cleopatra and the execution of Caesarion, her son by Julius Caesar, Egypt became a province of Rome. Roman influence affected every part of Egyptian life, from household utensils to religion. The Roman emperors continued to be shown as traditional pharaohs on temple reliefs. In practice, though, the country was a province administered by a prefect.

27 *Faience figurine of a child or small man, naked except for a broad collar. He is seated on a phallic stump with an elongated phallus falling to his ankles. The figurine is pierced, and was probably worn around the neck. Such erotica were fairly common in Ptolemaic times. H: 6.8 cm. Ptolemaic.*

The Roman emperor Constantine was a convert to Christianity and in AD 313 his Edict of Milan gave complete religious freedom to Christians, which, with a few exceptions, brought an end to their persecution. An edict of the emperor Theodosius in AD 392 ordered the closing of the 'pagan' temples in favour of Christianity. After the division of the empire into east and west in AD 395, Egypt remained part of the Byzantine empire until the Arab invasion of AD 640. Although a large proportion of the population adopted the new Christian religion (see Chapter 7), the old pharaonic religious beliefs continued, especially in southern Egypt, until the Arab conquest.

The Pharaoh

The king in ancient Egypt was regarded as a god. He was thought to be the incarnation of the god Horus, and was often called 'the good god'. At death, the king was identified with Osiris, the god of the underworld.

Kings are easily identified on Egyptian monuments. They normally wear a crown, a uraeus (a cobra on the forehead) and a false beard. The most important of the crowns were the tall bulbous White Crown of Upper Egypt, and the Red Crown of Lower Egypt shaped like a flat-topped cap with front spiral and rear projection upward. The Double Crown, a combination of White and Red, symbolised rule over the whole of Egypt.

The king's official titles consisted of five 'great names' which he assumed at his accession to the throne: three names (known as the Horus, Two Ladies and Golden Horus names, which referred to aspects of the king in relation to particular gods), the *prenomen* and the *nomen*. The *prenomen* is the name which follows the title 'King of Upper and Lower Egypt' (literally 'he who belongs to the sedge and the bee', the sedge plant symbolising Upper Egypt, the bee Lower Egypt). It is usually compounded with the name of the god Re. The *nomen*, the king's name before his accession and the name by which he is generally known to us today, follows the title 'son of Re'. The king's principal official name was the *prenomen*, which is often found alone or accompanied only by the *nomen*. The *prenomen* and *nomen* are written in 'cartouches' (a knotted loop of rope). For example, Ramesses II was Usermare Setepenre Ramessu Meryamun ('Strong in Right is Re, Chosen of Re, Ramesses, Beloved of Amun'), where the first two are the *prenomen*, the last two the *nomen*.

The word 'pharaoh' comes from the Egyptian *per-aa*, which means 'Great House'. This was used in the Old Kingdom to refer to the palace or court. Only in the 19th Dynasty did it come to be a respectful designation for the king, much as the head of the Ottoman Turkish government was called the Sublime Porte.

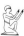

Central to the Egyptians' view of kingship was the concept of *ma'at*, which perhaps translates as 'justice', 'truth' or even 'harmony'. *Ma'at* referred to the ideal state of the universe and society, which it was the king's responsibility to maintain by making offerings in the temples either in person or by proxy through the priesthood. The death of a king was regarded as a period of chaos, threatening the stability of Egypt. The accession of a new king was the restoration of order, harmony, truth and justice, a re-establishment of the equilibrium of nature. In Egyptian literature of the Middle Kingdom, the First Intermediate Period is described as a period of chaos and anarchy, when all that was regarded as representing *ma'at* was turned upside down, rich men became beggars and beggars became nobles. The coming of a new king, probably Amenemmes I, is described as: 'Right (*ma'at*) shall come again to its place, and chaos is cast out.'

The daily life of the king was governed by ceremony. Anyone approaching him had to prostrate himself on the ground. Sinuhe, the hero of a Middle Kingdom story, describes an audience with the king:

I found his majesty on the great throne in a kiosk of gold. Stretched out on my belly, I did not know myself before him, while this god greeted me pleasantly. I was like a man seized by darkness. My soul was gone, my limbs trembled; my heart was not in my body, I did not know life from death.

28 *Sandstone relief depicting Tutankhamun presenting offerings to the gods, wearing the Blue Crown, the battle crown of Egyptian kings. His titles are carved in front of him: 'King of Upper and Lower Egypt, Nebkheprure, son of Re, Tutankhamun'. The name was partially rubbed out and replaced by that of his successor Horemheb. This usurpation may have been a result of a backlash against the pharaohs connected with the Amarna period. L: 38 cm. 18th Dynasty.*

In official reliefs, the king was presented as all-knowing and all-powerful. In the account of the Battle of Qadesh in northern Syria, inscribed on temple walls, Ramesses II is described as being surrounded by the Hittites. He charges the enemy from his chariot, kills vast numbers and fights his way out after being deserted by all of his troops, such are his superhuman abilities.

Egyptian kings did, however, realise that they carried a heavy burden of responsibility. An old king left these instructions for his son and successor:

Do not be evil, kindness is good . . . respect the nobles, sustain your people . . . do justice . . . calm the weeper, do not oppress the widow . . . beware of punishing wrongfully . . . do not kill, it does not serve you . . . do not prefer the well-born to the commoner, choose a man on account of his skills.

Ordinary Egyptians did not forget that the king was a man. Amenemmes I may have been the victim of an assassination, and in a literary composition probably composed after his death he is quoted as saying: 'Beware of subjects who are nobodies, of whose plotting one is not aware.' In the reign of Ramesses III there was a plot to assassinate the king in favour of one of his sons. The plot involved harem and court members, and important government officials.

29 *Official titles of Ramesses II written in hieroglyphs. At the top left is the title 'King of Upper and Lower Egypt', written with a sedge plant, symbolising Upper Egypt, and the bee, symbolising Lower Egypt. Top right is the title 'Son of Re'. Within the cartouches are (left) the* prenomen, *'Usermare Setepenre' ('Strong in Right is Re, Chosen of Re'), and (right) the* nomen, *'Ramessu Meryamun' ('Ramesses, Beloved of Amun').*

4
Writing in Ancient Egypt

Types of script

Three scripts were used in ancient Egypt: hieroglyphic, hieratic and demotic. Hieroglyphic (from the Greek *hieros*, 'sacred', *glypho*, 'sculptured') was used from the beginning of Egyptian history for all purposes. In later times it was restricted to monumental inscriptions; the last known hieroglyphic inscription, from Philae, dates to AD 394. Hieroglyphs were probably an offshoot of pictorial art, using pictures of things to denote names of other things which had a similar sound.

On stone, hieroglyphs were carved with a chisel. On papyrus, they were written rapidly with a reed pen and soon became abbreviated.

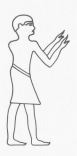

English	Hiero-glyphic	Hieratic	Demotic
b			
g			
h			
i			
m			
n			

30 *Signs written in hieroglyphic, hieratic and demotic scripts, with their English equivalents.*

31 *Ceiling pattern from the tomb of Neferhotep at Thebes, copied by Norman de Garis Davies. The name and title of the deceased are combined with spirals and floral motifs in a decorative scheme, showing the close relationship between Egyptian pictures and writing. Ceiling decorations in private houses appear to have been squares and rectangles in blue, red, yellow, black and white. 18th Dynasty.*

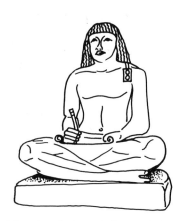

*32 Ivory pen case of Paser, vizier of
Ramesses II, from a tomb at Abydos.
Paser's titles are inscribed on the box.
In his own tomb at Thebes, Paser had
carved the traditional 'Royal Address
to the Vizier' which describes his duties
and enshrines high ideals of strict
impartiality and public justice. The
duties of the vizier were to receive
reports on the provisioning of the royal
estates, and to oversee court cases, the
spending of the state treasury, and
generally the smooth running of the
economy and state. The vizier was
answerable directly to the king and
may have stood in for him at religious
and state occasions when the king was
absent. L: 7 cm. 19th Dynasty.*

*33 A scribe in typical pose, sitting
cross-legged with a writing-board on
his knees. He holds a papyrus roll in
his left hand, with part of it open on
his lap, and a pen in his right hand.
Over his left shoulder is slung a palette
with cakes of black and red ink.*

This cursive script is called hieratic (Greek *hieratikos*, 'priestly', because by the Graeco-Roman Period it was used mostly by priests). About 700 BC a very rapid script developed, a cursive form of hieratic called demotic (Greek *demotikos*, 'popular'). By the Graeco-Roman Period this was the ordinary writing of everyday life, and was used until the mid-5th century AD.

There were two kinds of signs: phonograms and ideograms. Phonograms represented sounds and were used for spelling. Ideograms, or determinatives, conveyed the general meaning of the word. A picture of an eye, for example, did not simply mean 'an eye' but was added to the words 'look', 'search' or 'watch' to emphasise their meaning. One phonogram could represent one, two, three, four or even five consonants. Vowels were not indicated in the script. Most words were made up of a group of signs. There are 24 signs each representing one consonant, forming a core 'alphabet', but this was not developed and these 'alphabetic' signs were rarely used separately but nearly always in conjunction with other signs.

There was no punctuation in ancient Egyptian scripts and no spaces between words. Hieroglyphs especially were decorative and the signs were arranged symmetrically, written normally from right to left but sometimes from left to right or from top to bottom.

The scribe

The hieroglyphic script consisted of hundreds of signs, so few Egyptians could read or write. This was the job of professional scribes, although it is likely that the official class could read and write. Anyone could be sent to school to become a scribe, provided his parents could afford it. Schools were usually attached to temples, and boys were sent there from the age of four or five. The subjects taught were reading, writing, arithmetic, geography and history. The purpose of education was to train boys to become clerks, priests and artists. Girls did not go to school, and most remained illiterate.

School lessons consisted of repeated recitation and copying of standard texts, for example model letters, phrases and expressions, and mathematical problems, eventually leading to the classics of Egyptian literature, especially wisdom texts which gave advice on

morals and behaviour. School exercises were written on pieces of broken stone or pottery, or on wooden boards covered with gesso so that they could be wiped clean and re-used.

The final years of training were probably vocational, attending specialist schools in the palace, government departments, army or temples. The trainee would learn about surveying for tax assessors, and ritual practices or medicine for priests.

Writing materials

The Egyptians used many different materials on which to write: stone, wood, vellum, metal, pottery and leather. The most important was papyrus.

Papyrus once grew in profusion in the Nile valley, and each part of the plant could be used: for boats, ropes, sails, mats, baskets and sandals. Fine white paper was made from the pith. Narrow strips of the pith were cut, and two layers were placed together at right

34 *Wooden cubit rod, with the divisions of the cubit marked on it. The unit of length used to measure objects and short distances was the cubit, the length from elbow to fingertips of a tall man. This was divided into seven 'palms' and 28 'digits'. The divisions marked here are on average 19, 38 and 76 mm. The rod has a dedication to Amun-Re, Ptah and Thoth on behalf of Nakhy, a workman from the village of Deir el-Medina in Thebes. L: 52 cm. 20th Dynasty.*

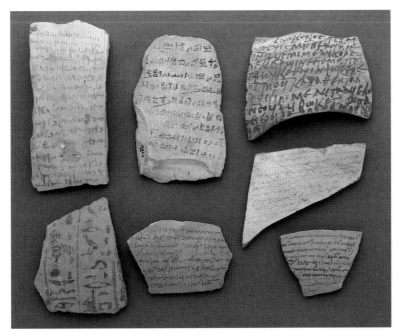

35 *Ephemeral letters and lists were written on pottery and limestone flakes like these, called ostraca from a Greek word meaning shell or sherd. Here are examples written in hieroglyphic, hieratic, demotic, Greek and Coptic, all the major scripts used in ancient Egypt. W (bottom right): 8 cm.*

36 *Hieroglyph representing a scribe's equipment, consisting of a mixing palette (right), a bag for the pigments, and a brush-holder. This sign was used as an ideogram or determinative in words concerned with writing and scribes. After the Early Dynastic Period, the pigments and brushes were held in the palette, but the hieroglyph continued to be used unchanged.*

angles. These were then either pressed or beaten into a long flat sheet. The sheets never exceeded about 48 cm in length and about 43 cm in width, but several sheets could be joined together to form a roll. The longest papyrus known is more than 40 m in length.

Documents of importance, such as official state records, legal documents and often letters were written on papyrus. Although papyrus was widely available it was used with economy. Letters, school lessons, inventories and notes were written on scraps of pottery or stone flakes called ostraca (plate 35), and on wooden boards. The diplomatic language used throughout the ancient Near East in the 2nd millennium BC was Akkadian, the language of Babylonia, written in cuneiform on clay tablets with a sharp wedge-shaped stylus. At Amarna, the royal records house contained large numbers of these documents along with hieratic translations on papyrus, indicating that some scribes not only learned Egyptian, but were proficient in foreign languages as well.

The scribe needed a palette and brushes to practise his profession. A scribe's palette was usually a rectangular piece of wood (plate 37). At one end were two or more cavities for holding black, red and other inks in the form of solid cakes. Black ink was made of carbon, probably burnt deposit from lamps, and red ink of red ochre. The scribe's brushes were of rush, the ends cut and chewed to break up the fibres. The brushes were kept in a slot in the palette. Pens made of reed, cut to a point and split at the tip, were first used by Greeks in Egypt in the 3rd century BC.

37 *Wooden scribal palettes with slots for brushes. Usually there are two circular holders for red and black ink. Occasionally palettes were made as tomb offerings, for use in the afterlife, with incised striations imitating brushes lying in the box. The scribal palette, bag for the pigments and pen form the hieroglyphs for 'scribe', 'writing', 'records' and so on. L: 32 cm, 26 cm. Middle and New Kingdom.*

Seals and scarabs

Personal seals were often carried or worn as rings. They could be inscribed with the owner's name. When impressed on wax or clay they acted as marks of ownership. During the Old Kingdom many such seals were cylindrical in shape, influenced by the cylinder seals of Mesopotamia (modern Iraq). Gradually they were replaced by seals shaped like the scarab beetle.

Scarab seals were the symbol of the creator sun-god Khepri. Scarab or dung beetles roll balls of dung, which they use as food, along the ground, and lay their eggs in similar dung balls. Egyptians regarded Khepri as a scarab pushing the globe of the sun across the sky because to them, new life sprang from the sun in the same way as new scarab beetles hatched from dung balls. Scarab seals originally served an amuletic purpose, but quickly became used as ordinary seals to authenticate documents, and to guarantee and seal goods.

Scarabs were made of all sorts of materials: carnelian, amethyst, faience, and most commonly steatite coated with a blue or green glaze. Scarabs can be inscribed with personal names and titles, or can bear patterns and good luck signs.

Scarabs could be issued officially to commemorate events. Amenophis III issued several sets of scarabs to commemorate his marriages to Queen Tiye and to a Mitannian princess, his killing of 102 lions, his hunting of 100 wild bulls, and the construction of a pleasure lake for Queen Tiye (plate 38).

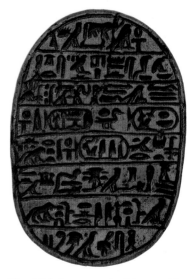

38 *This large scarab of Amenophis III, of glazed steatite, records that the king killed 102 lions by himself between the first and tenth years of his reign. L: 6.1 cm. 18th Dynasty.*

Egyptian literature

The main branches of Egyptian literature were historical records, religious and funerary texts, wisdom texts, meditations, pessimistic texts, poems, songs, hymns, magical and medical treatises, stories, myths, business and legal documents, and scientific and astronomical observations.

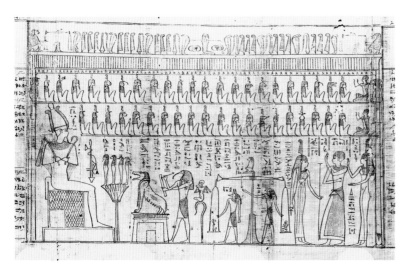

39 *Papyrus with sections from the Book of the Dead, an assemblage of funerary spells. These were to be recited by the dead person for protection against injury and demons, and to enable him to accompany the gods. Selections of these spells written on papyrus and often decorated with finely drawn illustrations were deposited in tombs as late as the Roman Period. This section shows the judgement scene, where the heart of the deceased (right) is weighed against the feather of ma'at (Truth, on the left) in the presence of the gods, while a demon with a crocodile's face (left) waits to devour the heart if it is judged unfit for the afterlife. This papyrus was prepared for Djedhor, son of the Lady Tapes, and placed in his tomb at Hissayeh. H: 50 cm. Ptolemaic.*

40 *Wooden stela, canopic chest and figure of Ptah-Sokar-Osiris belonging to the priest Nesshutefnut son of Iyhor and Teni, from his tomb at Hissayeh. The stela shows the deceased making an offering to seven gods (H: 40 cm). The inscription is a hymn praising the sun-god Re-Harakhte at his rising. The chest is in the shape of a shrine with the gods Thoth and Re-Harakhte shown drawing the bolts (H: 50.5 cm). A figure of Anubis, the jackal god of the underworld, would originally have been placed in front of and facing the figure of Ptah-Sokar-Osiris. Mummiform figures of the funerary god Ptah-Sokar-Osiris were often placed with burials (H: 64.5 cm). Ptolemaic.*

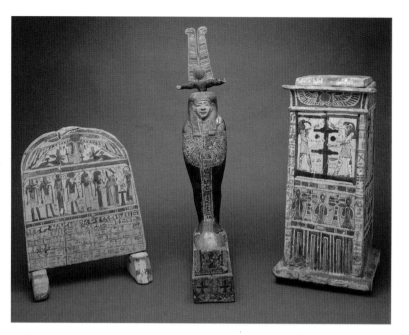

The collection of funerary texts known today as the Book of the Dead developed during the New Kingdom from older collections of spells (plate 39). To the ancient Egyptians it was the Book of Coming Forth by Day, containing about 200 spells, but there were collections of additional spells. On papyrus the texts were inscribed in black ink in vertical columns of hieroglyphs with important points highlighted in red. Illustrations to some spells were drawn in black outline and later coloured. The texts described the underworld and all its obstacles. The papyrus rolls containing these texts were placed between the legs of the mummy, and later inside special figures in the form of the funerary god, Ptah-Sokar-Osiris (plate 40).

Business records were often written on flakes of limestone or pottery ostraca, because papyrus was too expensive to be used for all records. Bureaucratic or administrative texts were more usually written on papyrus rolls. Some of these documents can be very informative for specific events in history, for example Papyri Mayer A and B, written in the hieratic script in black with headings in red (plate 41). Both papyri belong to a series of hieratic texts that record the arrest and examination of men and women accused of robbery of royal tombs and sacred places on the west bank of Thebes during a period of civil disorder towards the end of the New Kingdom. The smaller record, Papyrus Mayer B, documents part of the trial of men accused of robbing the tomb of Ramesses VI

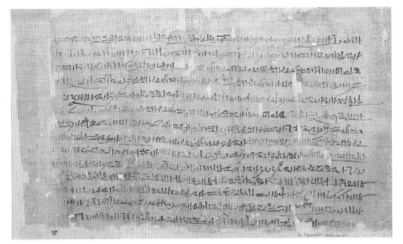

during the 20th Dynasty. The text gives the confessions of the robbers and details their disputes over the spoils. The larger record, Papyrus Mayer A, dates to the reign of Ramesses XI, last king of the 20th Dynasty (*c.*1095 BC). It relates to men and women accused of stealing objects from royal tombs at Thebes and from gilded portable shrines. The testimony of both the accused and the witnesses was given under oath and after a beating on the soles of the feet.

Egyptian scientific literature comprises mathematical problems: addition, multiplication, fractions, areas and problems specific to building works like the erecting of pyramids and obelisks. Astronomy was practised from very early on in Egyptian history. Detailed records of the movement of the planets were kept. Some of these are recorded on four gesso-coated wooden tablets inscribed in demotic during the reigns of the Roman emperors Trajan and Hadrian (*c.*AD 63–140) (plate 42). The tablets are more correctly leaves of a type of book used in Graeco-Roman times for accounts, school exercises, letters and notes. The texts relate to the movements of the stars and moon within the zodiacal signs. Originally there would have been 11 such tablets. They were used for casting horoscopes, a science derived from the influence of Babylonian astrology in the Graeco-Roman world.

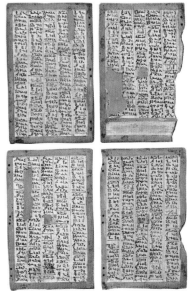

42 *Four wooden tablets, covered in gesso and painted white, inscribed in demotic with observations of the planets during the reigns of Trajan and Hadrian. There are five vertical columns of writing on each, and each tablet has three pairs of holes for binding. H: 11.4 cm. Roman Period, c.AD 63–140.*

5
The Crafts of Life

Metalwork

Egypt, particularly the eastern desert, is relatively rich in metal sources, especially gold, silver, copper, iron and zinc. These last two metals were not really exploited; in fact the iron that has been found made into objects is meteoric in origin. Lead was used in the form of galena or haematite from the Red Sea coast area to make eye paint (kohl), small items of jewellery and net sinkers.

Tomb scenes from the 4th Dynasty on show the skills and techniques of the metalworker. These scenes include the brazier where the metal was smelted or annealed. During the Old and Middle Kingdoms braziers were heated by using blowpipes. By the 18th Dynasty foot bellows had been introduced. Molten metal in crucibles was taken from the brazier using two green wooden sticks and poured into moulds. When the metal cooled enough to work, it was hammered. Objects made of copper and bronze include tools, weapons, household and toiletry items. The majority of bronze statues and figures are from the Saite 26th Dynasty and Ptolemaic Period (plates 43, 93–9). These are predominantly of gods, such as Osiris, and Isis suckling the baby Horus. Sacred animals, particularly cats and ibises, were very popular.

These figures were made using the lost wax technique. The figure was first modelled in wax and coated in clay. During the heating of the mould the wax would melt and was poured away leaving a perfect mould. The molten metal was then poured into the mould. When the metal had cooled the mould would be broken away, and any surplus metal trimmed and details added by chiselling. Larger figures were made with a solid core coated with wax. When the molten metal was introduced into the mould the wax was burned off leaving a figure with a solid core.

43 *Bronze figure of Osiris, a particularly fine example, with eyes inlaid with silver, wearing the* atef-*crown and uraeus, holding a flail and crook, and with a royal beard. The pedestal has a dedication on behalf of Tetebastiuesankh, daughter of Petekhons and Harbast. H: 23 cm. 26th Dynasty.*

36

Woodworking

Good quality wood was not available in Egypt, so native timber was restricted to small objects. Local woods were palm, acacia, sycamore and tamarisk. Imported woods were predominantly cedar and pine from Lebanon, and ebony from Nubia or Punt (a country identified with modern Somalia).

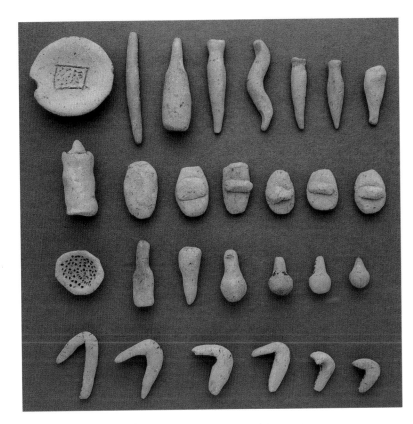

44 *Sets of model tools placed in a tomb were believed to ensure that they would be available for use in the afterlife. The wood and copper set from Beni Hasan (below) reproduces exactly in miniature the chisels, saws and drills of a craftsman. The second set, made of clay (left), was found in a grave at Esna. The domestic items include models of jars, loaves, grinding stones for grain, as well as sieves, pounders, adzes and a yoke for carrying loads. L (copper saw, bottom, 3rd from right): 10.7 cm. Middle Kingdom.*

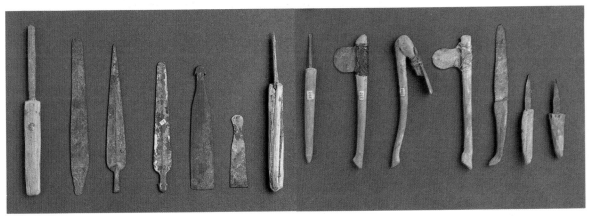

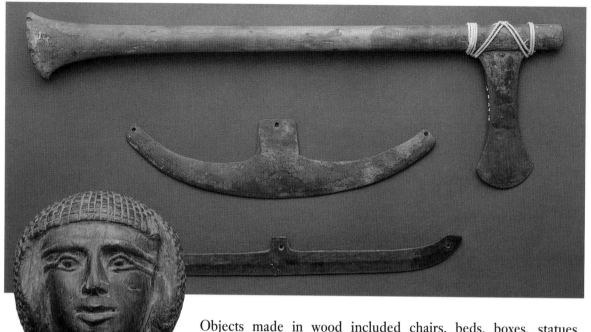

45 *(Top) copper alloy axes from Rifeh (top) and Beni Hasan (middle). The one at the bottom is unprovenanced, but is similar to axes of about the same period in Palestine. In the Old and Middle Kingdoms there was little difference between axes used as carpenters' tools and those used as weapons. The axes at the bottom and in the middle were probably battleaxes. The axe blade at the top may have originally been mounted as a form of halberd, a spear shaft fitted with an axe blade used for cutting and slashing. L (bottom): 30.5 cm. Middle Kingdom.*

46 *(Above) wooden head of a man wearing a tightly curled wig and showing the lines of eye paint. This head, said to be from Esna, was bought by John Garstang in Luxor. H: 11 cm. Old Kingdom.*

Objects made in wood included chairs, beds, boxes, statues, head-rests, penholders, handles, cosmetic vessels, as well as boats, chariots and coffins (plates 46–8). The tools used by the ancient carpenter can be seen in sets of miniature tools (plate 44). They included a bow drill, adze, axe, pull saw, chisel and bradawl. The cutting edges were made of copper or bronze set into wooden handles. The carpenter also used a wide-headed wooden mallet.

Wood was cut to size using axes (plate 45). Thick planks were then tied to a post set in the ground, a type of ancient work-bench and vice, and cut with a pull saw. Objects were shaped using the adze, and finishing and details were done with the chisel.

Furniture-making was a particular skill of the Egyptian craftsmen. They used fine veneers and combined wooden inlay with ivory to produce the same patterns achieved by the painter. Decorative motifs were taken from nature in the form of lotus flowers and animals for inlay, handles and chair legs.

Wooden figures appeared less rigid than painted or stone ones because wood allowed the sculptor to make a statuette in several pieces which could be pegged together. Usually the arms and fronts of the feet and occasionally the face were made separately. As wood is a light material, the arms and legs could be freed from the body and placed in virtually any position. Wooden statuettes could have inlaid eyes and were frequently painted or gilded.

38

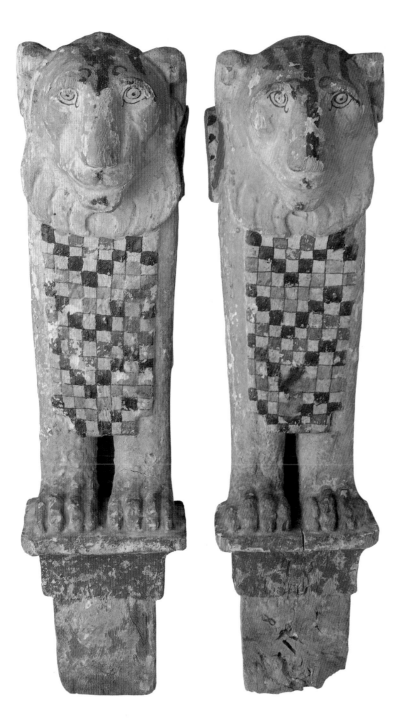

47 *(Left) pair of painted wooden legs in the form of lions. Articles of furniture such as beds and chairs were often dismantled so that they would fit into a small burial chamber with other offerings. Lion legs were popular on Egyptian chairs, which normally had backs but no arms, and wooden seats or seat-frames with inlaid seat panels. It is likely that these examples come from a funerary bed of the Roman Period. H: 50 cm.*

48 *(Below) wood statuettes of the brothers Nebreshy and Amenhotep, sons of Nefer and Sankhrenef, with shaven heads and wearing pleated kilts. The arms hang stiffly at the sides, carved in one piece with the body, unlike the majority of wooden figures. Both inscriptions are dedications to Osiris made for the brothers by their parents. H: 27.3 cm. Early New Kingdom.*

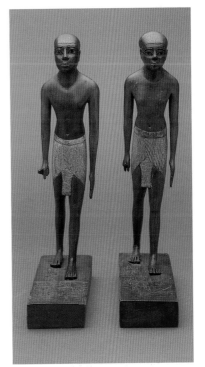

Faience and glass

Faience is the name given to glazed composition. Many small objects were made of faience or were combined with other materials in larger objects. The technology to produce it was known as early as the Predynastic Period. The nature of the material lent itself to mass production, particularly objects which could be made in open moulds (plate 49). It was also malleable and cheap to make. Hence, items like finger rings and beads were produced in great numbers, as well as amulets, pendants, small figurines, ushabti figures, inlays and tiles. Faience was also used to produce glazed vessels in the form of cups, dishes and jars (plates 50–2). All are glazed a rich vivid blue with aquatic and floral motifs. Scarabs were the commonest of all objects either made entirely of faience or with a glaze.

The glaze was made from a silica base, like quartz sand, combined with natron which when heated produces a viscous material. The glaze could only adhere to an alkali core like quartz or steatite, or a composition of fine crushed quartz, quartz pebbles or rock crystal

49 *Clay one-part moulds for casting faience amulets and inlay tiles, from Amarna. Motifs on amulets are naturalistic and ritual, of daisies, lotuses and lilies, as well as* wedjat-*eyes and royal names. The double cartouche here contains the names of Akhenaten. W (*wedjat*): 5.5 cm. 18th Dynasty, reign of Akhenaten.*

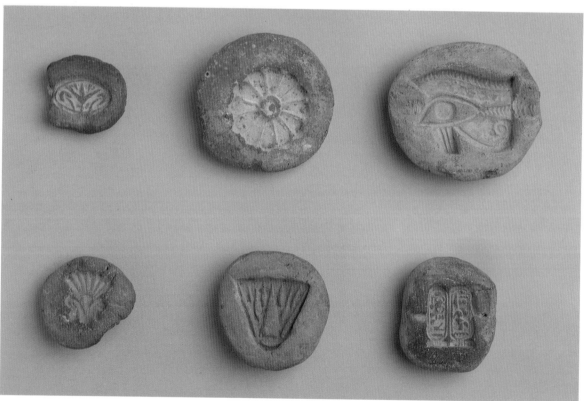

in a solution of salt or natron to bind it. The resulting material was easy to mould with the fingers or put into an open mould. It is probable that the glaze was applied to the core in a viscous state, the two becoming fused during firing.

The commonest colour for faience is blue or green, or a blueish-green, but white, yellow, red and purple were also made. The colours were achieved by adding iron oxide or antimony combined with lead for yellow, cobalt oxide for blue, copper oxide or iron oxide for green, iron oxide for red and black, and manganese oxide for purple. White was made by adding no colouring agent.

50 *(Below left, top) faience figure of a monkey from Hierakonpolis. Monkeys and baboons were often depicted in painting and sculpture. Baboons were known for shrieking loudly before dawn, so in later periods they are depicted on tomb walls as a symbol of resurrection, encouraging the sun to rise. H: 5.7 cm. Early Dynastic Period.*

51 *(Below left, bottom) faience bowl from Abydos decorated as a pool with fish surrounded by lotuses. The colouring of pale and dark blue is well suited to this aquatic subject. D: 16.7 cm. 18th–19th Dynasties.*

52 *(Below) faience figure, from Esna, of a dwarfish lion demon, forerunner of the household god Bes, popular from the early New Kingdom onwards. H: 8.6 cm. 12th–13th Dynasties.*

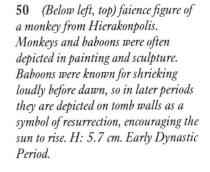

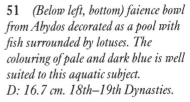

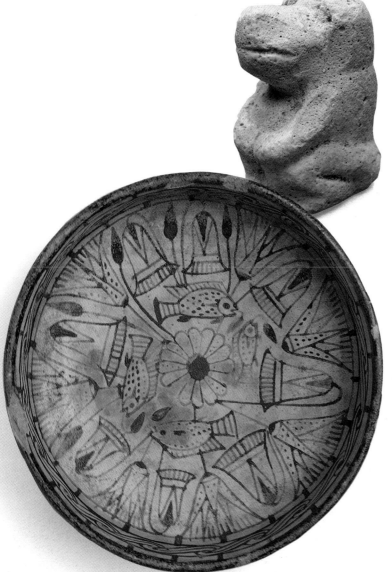

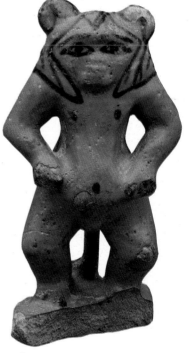

53 *(Below) glass alabastron (in the shape of popular vessels made of alabaster), core-formed, with two yellow glass projections on the body. H: 15.2 cm. 18th Dynasty.*

54 *(Below, right) Greek influence can be seen in the shapes of these glass vessels, which may have been imported into Egypt from Phoenicia on the Syrian coast. They originally contained perfumes and oils. The multi-coloured designs were achieved by trailing soft rods of glass over the blue body surface, rolling the vessel on a flat stone and then dragging a sharp implement across the surface while it was still soft. H (tallest): 15 cm. Late Dynastic Period.*

The technology to produce glass is the same as that for faience glaze. It was used during the Old and Middle Kingdoms to make beads and amulets, but larger objects did not appear until the 18th Dynasty (plates 53–4). Unlike modern or Roman glass, ancient Egyptian glass does not contain lead and is not clear. It was made by heating quartz sand or ground quartz with natron until it formed a viscous mass called frit. The frit was cooled and ground up, then reheated to form glass. To this were added colouring agents, initially ground malachite or cobalt for a deep blue. The material was usually left in a lump to cool or pulled out into rods for future use.

Glass was used to make a variety of small cosmetic containers. They were made using a clay core held in a cloth bag to form the inside of the vessel, which was fixed to a metal or wooden rod. The core was dipped into the molten glass and turned to cover the core and create the body. While still warm the craftsman formed a foot, a lip, a spout if it was a jug, and would apply a separate handle. When the glass had cooled the clay core could be removed.

During the New Kingdom the vessels became more decorative using a distinctive technique known as 'dragging'. While the body of the container was still hot, rods of different coloured glass were applied to the surface, either in straight lines or in loops. The body temperature was sufficient to melt the rods and the whole was then rolled on a flat stone. Across this striped design a sharp instrument

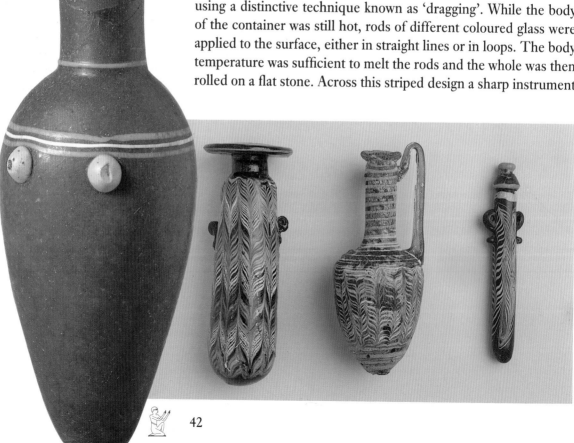

was dragged first upward then downward to make a zigzag pattern. The coloured rods were in pale blue, pale green, purple, yellow and white.

Pottery

Two types of clay were available to the ancient Egyptian potter. One was alluvial mud from the bed of the Nile, used for utilitarian vessels and objects. The other was higher quality marl clay from shale beds between limestone layers in the desert from Ballas to Qena in Upper Egypt, reserved for specialised pottery forms and luxury items.

In the Predynastic Period pottery was made by coiling and smoothing (plate 55). By the Old Kingdom a wheel was used: a turntable, with a wooden platform for throwing the clay, was placed on a stone pivot or flywheel which the potter turned with one hand while shaping the clay with the other. Kick wheels were not introduced until the Late Dynastic Period.

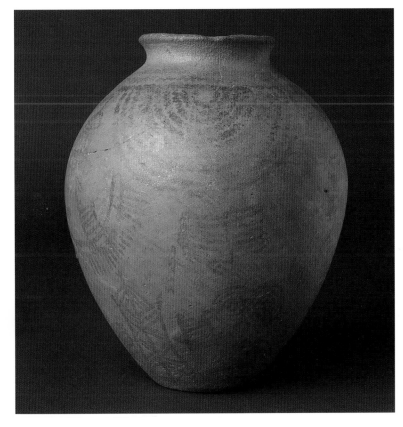

55 Predynastic vase decorated with red paint. The motifs on the vase, which include ships with many oars, trees, standards and ostriches, were common not only on pottery towards the end of the Predynastic Period, but also in the earliest known Egyptian wall painting, a painted tomb at Hierakonpolis. H: 22 cm. Predynastic.

56 *Large pottery bowl decorated with blue lotus flowers, with red details and black outlines, from Amarna. The bowl imitates the form of the white lotus. Blue-painted pottery seems to have been made only at royal residences or palaces, and was therefore produced by a small number of craftsmen in a few workshops. It was used for ornament, in the house, in religious contexts, and in tombs. This restored example originally had a foot, now missing. H: 21.5 cm. 18th Dynasty, reign of Akhenaten.*

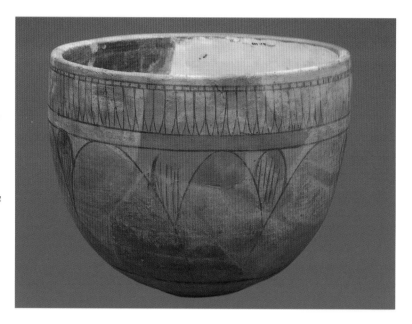

Pottery vessels were used for food and liquid in daily life (plates 56–7). Similar containers for religious use were made of higher quality marl clay. Pottery was also made for funerary use, to hold offerings, as model vessels, and during the Early Dynastic Period to hold the body of the deceased. Canopic jars were also frequently made of pottery. Pottery bread moulds were made over a wooden template, fired, filled with dough, cooked and then broken to release the bread. Imported pottery attests to trade in goods between Egypt and her Near Eastern and Aegean neighbours. Pottery was imported largely for what it contained. Once the contents, which may have been oil or cheese or some other comestible, had been used the vessel could be re-used.

57 *Jar from the Faiyum with the face of the god Bes modelled on the surface in incised and applied relief. Bes jars were made from the 18th Dynasty until Roman times. Since Bes was a household god, protecting children and women in childbirth, he was an appropriate image for decorating household pottery. H: 18 cm. New Kingdom.*

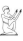

Textiles

The main cloth used by the ancient Egyptians was linen made from flax. Wool was not widely used for clothing probably because wool-bearing sheep were not reared in Egypt until the Middle Kingdom. Silk was introduced in the Ptolemaic Period, while cotton was not used until the Roman Period. The majority of linen found today is in the form of mummy bandages and sheets neatly folded and placed in the coffin for the dead person to use in the afterlife.

The surviving textiles, from as early as the Predynastic Period, indicate that a variety of cloth qualities was produced. It is likely that the very finest linen was woven in the palace workshops and reserved for royal use. The production of linen was largely a cottage industry, each estate having its own spinning and weaving shop.

A tomb model from Beni Hasan shows a woman spinning thread of the finest quality, her spindle being left to spin under its own weight (plate 58). This is a particularly adept spinner because she is able to spin two threads at once, the other spindle being held in the hand. Two other women squat next to a horizontal loom painted on the base of the model, the threads indicated in black paint. The vertical loom came into use in the early 18th Dynasty.

58 *Painted wooden model from Beni Hasan. One woman stands spinning thread: she holds the thread in her hand while the spindle revolves. Two other women are using a horizontal loom which has been painted on the base of the model. Placed in the tomb, this model would ensure the deceased an unlimited supply of linen for clothing. L: 26.1 cm. Middle Kingdom.*

59 *The 'Ramesses Girdle', a linen cloth 5.2 m long, and tapering from 127 mm to 48 mm in width. The design consists of stripes, zigzags, dots and rows of* ankh-*signs in blue, red, yellow, green and white linen. At one end is the now deteriorated cartouche of Ramesses III and his second regnal year date. The band was probably woven on a simple loom, and it has been estimated that it took from three to four months to complete. It would have been wound several times round the waist, and secured by pulling the narrow tasselled end through the two loops at the wide end. Probably from Thebes, 20th Dynasty.*

Egyptian clothes were normally quite plain. Linen is naturally coloured white to yellowish-brown depending on the age of the harvested flax. Some dyes were used to produce cloth of a red or blue colour, but because of the difficulty of obtaining the fixer or mordant, in this case alum, coloured and patterned weaves are uncommon. Patterned textiles depicted in paintings are worn mostly by foreigners. Goddesses and queens are also depicted wearing patterned dresses. It is likely that the patterns are those achieved by embroidery and by sewing beads onto the fabric.

The so-called 'girdle' of Ramesses III comprises a thin band of cloth over 5 m long (plate 59). The pattern is in three stripes made from extra warp threads forming two coloured bands separated by a plain band. The wide end of the 'girdle' had ink cartouches containing the name of Ramesses III, now lost.

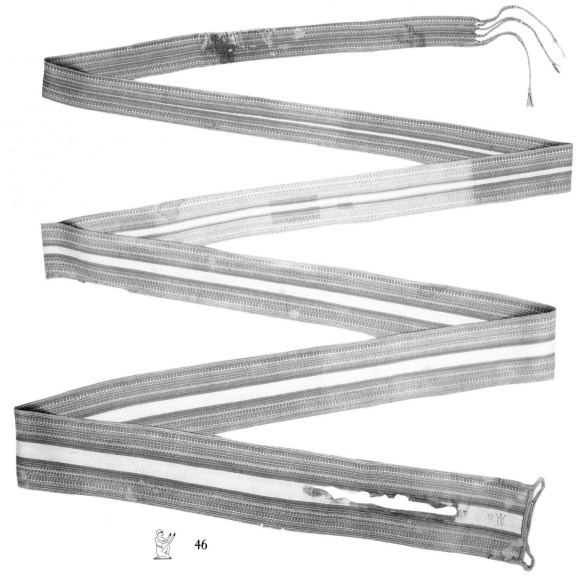

Basketwork

The use of mats and baskets is known as early as the Predynastic Period for floor and wall coverings and for containers. Mats were made on a horizontal loom similar to that for linen production, using grasses and reeds. Baskets were used as containers similar to pottery vessels and wooden boxes (plate 60). They were made mostly of palm leaf coiled spirally about the frame. Palm leaf was also used for ropes and sandals (plates 61–2). Most ancient Egyptians walked barefoot, and sandals indicated that the wearer was relatively well-off. Sandals, of palm leaf or leather, consisted of a sole to which were fixed straps for holding the foot.

60 *Baskets made of leaves, papyrus or cane, coiled spirally, were used as containers in the home. This tiny example is only 7 cm high. Middle Kingdom.*

61 *(Left) a pair of sandals made of neatly plaited palm leaf with ornamental edging. The toe straps are lost. Egyptians were barefoot most of the time, and sandals were reserved for special occasions. Ancient Egyptian etiquette meant that sandals had to be removed in the presence of a superior. It was an honour to carry the sandals of a great man, and the title 'sandal bearer' is known from earliest times. L: 30 cm. New Kingdom.*

62 *Pair of wooden model sandals from a tomb at Beni Hasan, painted to resemble hide. L: 24 cm. Middle Kingdom.*

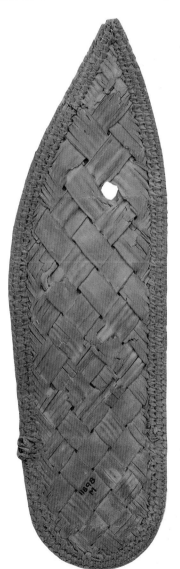
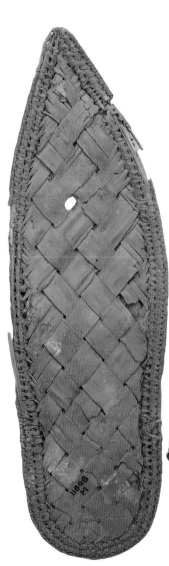
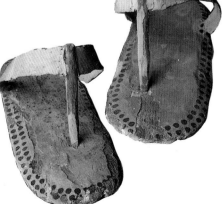

47

Toys and games

Tomb scenes record a great variety of pastimes, and objects recovered from tombs can often be identified as toys and games. Musical instruments included the harp, lyre, lute, clarinet, flute, oboe, tambourine and drum (plate 63). Musicians were often depicted at banquets, a favourite scene showing a blind male harpist.

63 Fragment of wooden musical instrument with ivory and ebony pegs, from a tomb at Abydos. This is probably the neck from a harp, which would have held the strings attached to a sound box shaped like a boat. Harps first appeared in the Old Kingdom. They had a similar range to modern violins, and were most often played together with other instruments. L: 62 cm. 19th Dynasty.

Board games were very popular, especially *senet*, which is frequently found in tombs and depicted in paintings (plate 64). Sometimes the accompanying text gives instructions on play which has enabled the rules of the game to be reconstructed. Its object was to get one's pieces off the board and prevent the other player from doing so. The board was divided into three rows of ten squares. It could be made of limestone, steatite or faience. Moves were determined by throwing sticks with one flat and one rounded side, or knuckle bones made of bone, ivory or steatite. Gaming pieces were often in the form of animals or gods and occasionally captive foreigners (plate 66).

Children played with balls, dolls, spinning tops, rattles, toy animals and marbles. Balls were made of leather, wood or glazed pottery. Rattles were usually of pottery. Figures of wood or limestone with heavy wigs were interpreted by early archaeologists as dolls. These are now thought to have had some religious function (plate 65). Model animals of mud and limestone included horses, birds and baboons.

64 Faience board for the game of senet, with four pieces, from Abydos. Egyptians loved board games and they were commonly placed as tomb offerings or depicted on tomb walls and sides of coffins. Senet is known from Predynastic times to the late Roman Period, and even today in Egypt and Sudan there is a similar game. Senet, like other ancient Egyptian games such as 'hounds and jackals', was played by two people. L: 17 cm. New Kingdom.

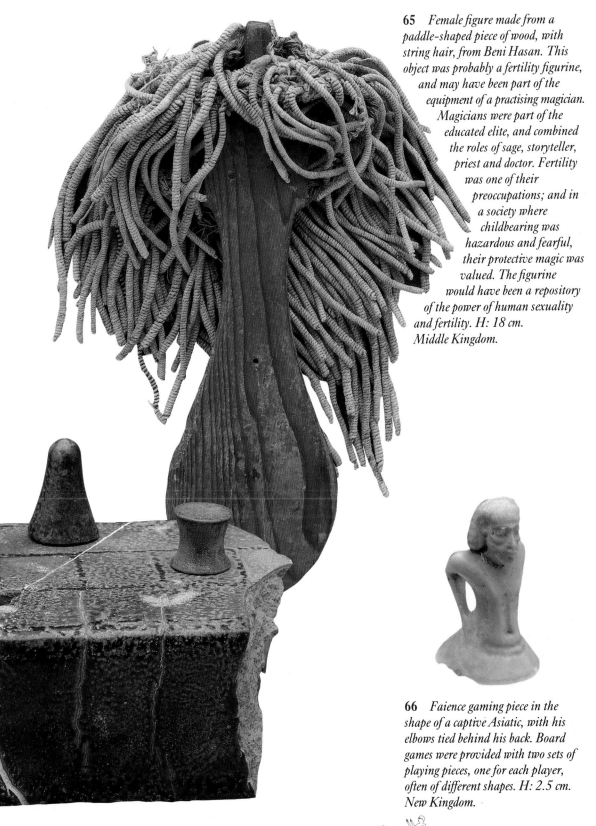

65 *Female figure made from a paddle-shaped piece of wood, with string hair, from Beni Hasan. This object was probably a fertility figurine, and may have been part of the equipment of a practising magician. Magicians were part of the educated elite, and combined the roles of sage, storyteller, priest and doctor. Fertility was one of their preoccupations; and in a society where childbearing was hazardous and fearful, their protective magic was valued. The figurine would have been a repository of the power of human sexuality and fertility. H: 18 cm. Middle Kingdom.*

66 *Faience gaming piece in the shape of a captive Asiatic, with his elbows tied behind his back. Board games were provided with two sets of playing pieces, one for each player, often of different shapes. H: 2.5 cm. New Kingdom.*

67 *Wooden comb with one row of teeth. Combs are often found in baskets with other cosmetic articles. The Egyptians were particular about personal hygiene and grooming, resulting in the use of an array of tweezers, razors, combs and mirrors. L: 8 cm. New Kingdom.*

68 *Alabaster kohl pots of Middle to New Kingdom date. The one at the back left is a double vase with two crouched monkeys supporting it at either side. Monkeys appear frequently in domestic scenes in tomb reliefs, showing that they were kept as pets. They were also erotic symbols, which perhaps explains their association with cosmetics. H (monkeys): 8.3 cm.*

Cosmetics and toilet articles

Tomb paintings show the heavily elongated and darkened eyes of Egyptian women. This was achieved by the use of a paste or powder called kohl, produced from malachite (green oxide of copper) or galena (grey sulphide of lead). Green eye paint represented the eye of the god Horus, and so had a magical protective function. Kohl made from malachite was also used as an ointment against eye infections, since copper prevents the penetration of bacteria. Egyptian women painted their lips with red ochre mixed with oil or fat. Red ochre on its own could be used as a rouge. Henna was used to colour the soles of the feet, the palms of the hands, nails and hair. There are prescriptions in medical papyri for making hair grow, preventing it from turning grey, combating dandruff, removing unwanted hair, wrinkles and spots, and improving the skin.

Toilet articles included kohl pots, cosmetic palettes, bowls, spoons, tweezers, combs, pins and mirrors (plates 67–71). Kohl containers are among the most common articles found in tombs. In the Middle and early New Kingdoms, they were squat stone jars with wide rims. During the New Kingdom a new type developed, a tall tube made of alabaster, ivory, wood or glass, often inscribed. These

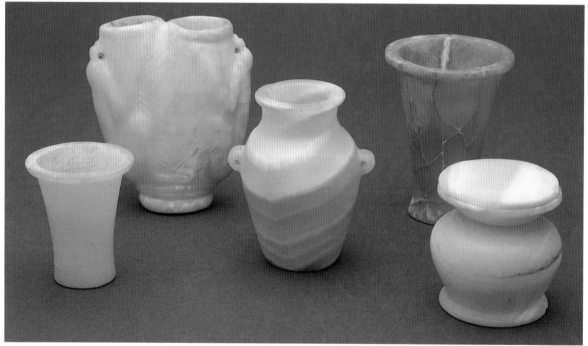

became very elaborate, and were decorated to represent bundles of reeds, palm columns or animals, particularly monkeys. Originally kohl would have been applied with the fingers, but from the Middle Kingdom a kohl stick was used. This was a thin stick with a bulbous end, made of ebony, wood, bronze, haematite or glass.

69 (Left) steatite cosmetic tray in the form of a slaughtered ibex. Details of the horns and tied legs are carefully indicated. The other side of the body has been hollowed out as a bowl. L: 6.7 cm. New Kingdom.

70 (Right) wooden kohl pot with five holes and a smaller hole for the stick, decorated to represent a bundle of reeds. The lid is of ivory with ebony and ivory pegs. The inscription at the front mentions the owner, Neferemheb, a priest of Amun. H: 7.3 cm. 18th Dynasty.

71 (Bottom) Kohl pots of stone, faience and bone. The love of nature influenced the design of some domestic items like kohl pots. One is in the form of a monkey holding a cylinder, and one of a hedgehog. Representations of hedgehogs occur in all periods in Egypt, sometimes among tomb offerings, suggesting that they had protective significance. Hedgehog fat or oil was reputed to cure baldness. H (left): 4.2 cm. New Kingdom.

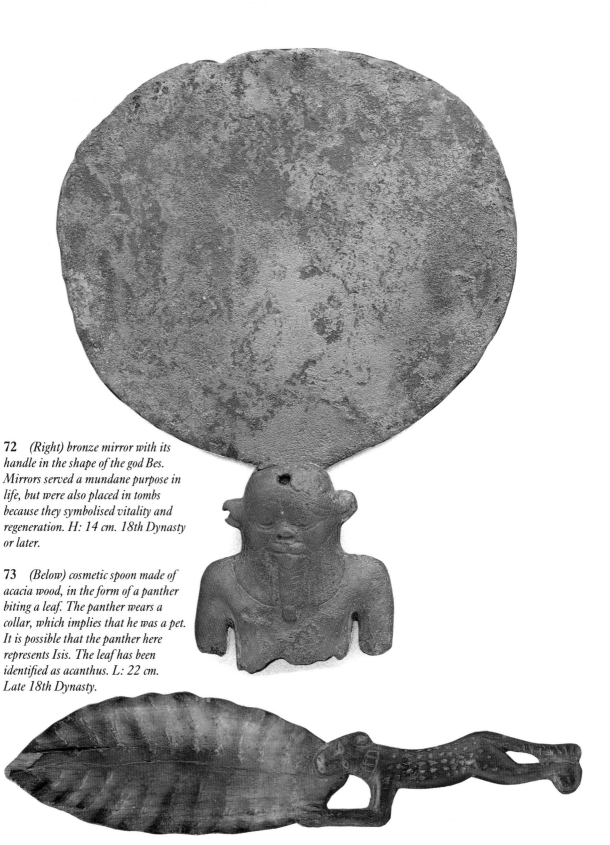

72 (Right) bronze mirror with its handle in the shape of the god Bes. Mirrors served a mundane purpose in life, but were also placed in tombs because they symbolised vitality and regeneration. H: 14 cm. 18th Dynasty or later.

73 (Below) cosmetic spoon made of acacia wood, in the form of a panther biting a leaf. The panther wears a collar, which implies that he was a pet. It is possible that the panther here represents Isis. The leaf has been identified as acanthus. L: 22 cm. Late 18th Dynasty.

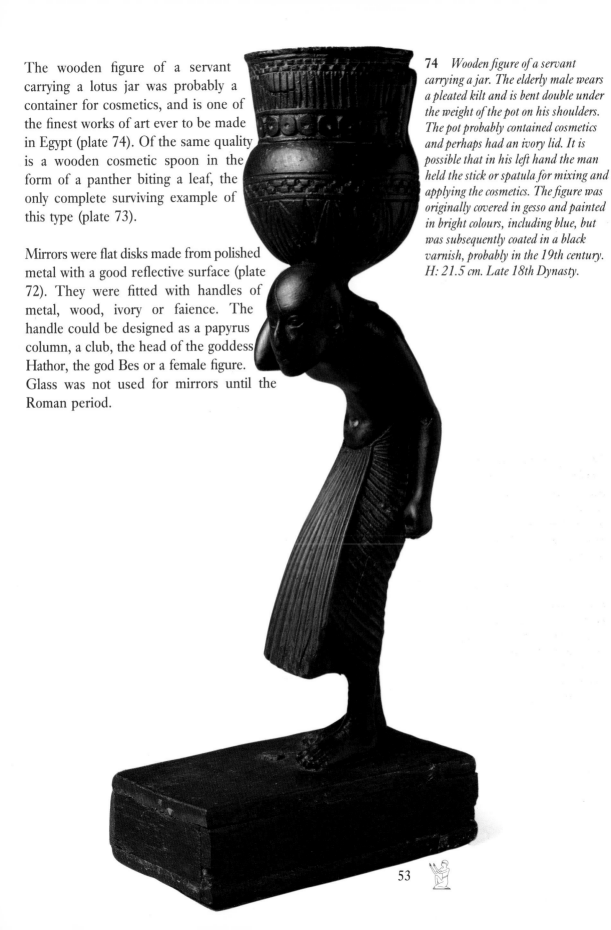

The wooden figure of a servant carrying a lotus jar was probably a container for cosmetics, and is one of the finest works of art ever to be made in Egypt (plate 74). Of the same quality is a wooden cosmetic spoon in the form of a panther biting a leaf, the only complete surviving example of this type (plate 73).

Mirrors were flat disks made from polished metal with a good reflective surface (plate 72). They were fitted with handles of metal, wood, ivory or faience. The handle could be designed as a papyrus column, a club, the head of the goddess Hathor, the god Bes or a female figure. Glass was not used for mirrors until the Roman period.

74 *Wooden figure of a servant carrying a jar. The elderly male wears a pleated kilt and is bent double under the weight of the pot on his shoulders. The pot probably contained cosmetics and perhaps had an ivory lid. It is possible that in his left hand the man held the stick or spatula for mixing and applying the cosmetics. The figure was originally covered in gesso and painted in bright colours, including blue, but was subsequently coated in a black varnish, probably in the 19th century. H: 21.5 cm. Late 18th Dynasty.*

75 *Gold, silver, carnelian and glass jewellery excavated by John Garstang in 1909 from an undisturbed tomb at Abydos. The gold-mounted jasper scarab is inscribed with the cartouche of Tuthmosis III. W (top left): 2.6 cm. Late 18th Dynasty.*

Jewellery

The range of jewellery for men and women included collars, pectorals, necklaces, diadems, bracelets and anklets, finger rings, ear-rings and girdles (plates 75–82). Although it was worn for adornment, much jewellery had magical significance to protect the

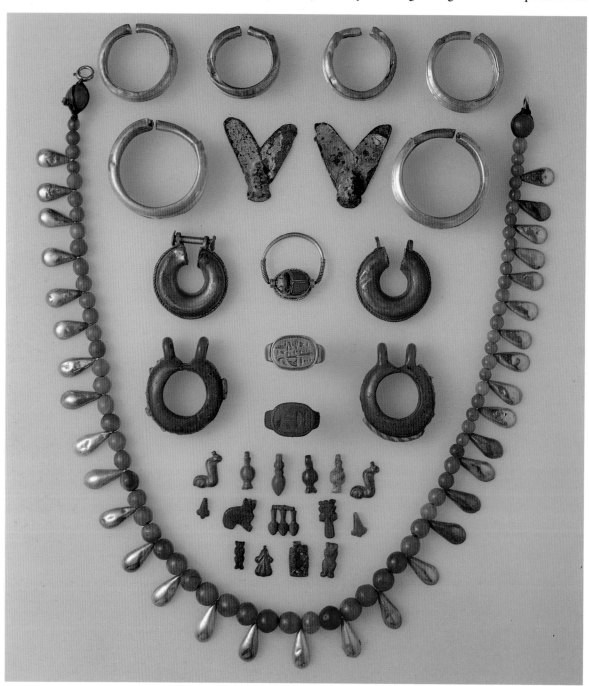

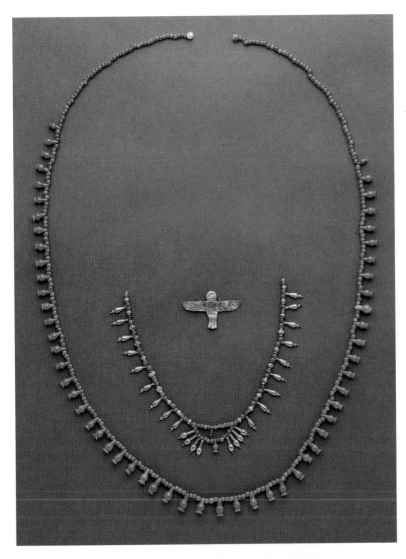

76 *Two carnelian necklaces with beads in the form of gold hes-vases and carnelian cornflower pendants, and a gold cloisonné pendant in the form of a hawk with the remains of faience inlay. The hes-vase pendants resemble the characteristic ancient Egyptian water jar, and stand for the hieroglyph for 'praise' or 'favour'. W (hawk): 4.8 cm. New Kingdom.*

77 *(Below) two gold signet rings, said to be from the royal tomb of Akhenaten at Amarna. One depicts a lion dancing with a tambourine. The second shows two figures of the domestic god Bes wearing wide flaring head-dresses and carrying knives in each hand, between two ankh (life) signs. H: 2 cm. 18th Dynasty.*

78 *Necklaces made from gold beads. Gold was available from several places, but particularly from Nubia. It is possible that the Egyptian word for gold, nub, is the origin of the name 'Nubia', which would literally mean 'gold land'. D (right): 10 cm. New Kingdom.*

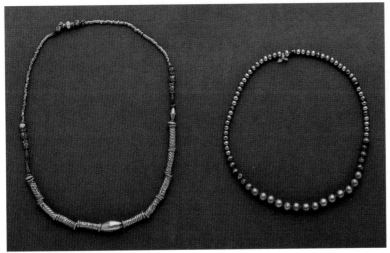

79 *Ear decorations were worn by men and women. The two glass examples are pendants, worn on a wire suspended from the ear-lobe. The calcite ear stud was pushed through pierced ear-lobes. L (right): 3 cm. New Kingdom.*

80 *(Right) gold and silver bracelets. The ends of two of the bracelets resemble rams' heads, with gold wire twisted round the rods portraying the horns. The Egyptian word for 'silver' literally meant 'white gold'. Most silver was imported into Egypt from Asia, Cyprus and Crete. Silver was symbolically linked with the moon and was thought to be the material from which the bones of the gods were made. D (bottom right): 6 cm. New Kingdom.*

81 *(Below, right) mummified left hand of a woman, acquired in Egypt in 1854–5. It was covered with a fine linen wrapping, leaving the fingers free, and thickly coated with bitumen which has remnants of gilding. On the first and second fingers are rings shaped like obelisks, the shafts made of lapis lazuli and the bases of gold. There are two other gold rings: one plain, the other with a scarab of lapis lazuli. Imported from the area of modern Afghanistan, lapis lazuli was much prized for its colour. L: 21 cm. Roman Period.*

82 *(Far right) gold ring of Amenophis II with a revolving bezel naming him: 'The good god, son of Amun, powerful lord, warrior, contending against hundreds of thousands, son of Re, Amenophis, golden god, ruler of Heliopolis'. L: 2 cm. 18th Dynasty.*

wearer from harm. Many pieces of jewellery took the form of amulets like the *wedjat* or sacred eye of Horus, the scarab, small figures of gods, and parts of the human body such as the heart, leg or hand.

Elaborate ear-rings appeared at the beginning of the New Kingdom, but simple hoops are found from the 13th Dynasty. Hooped or penannular ear-rings were made of gold rods bent and soldered together, forming a wide ribbed hoop. Ear studs were mushroom-shaped, usually made of alabaster or aragonite, glass or faience.

Bracelets were at first rigid circles of metal, stone, shell or ivory, but later they were made as two semicircles joined by a hinge and clasp, resembling bangles.

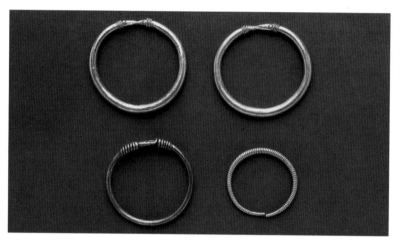

Finger rings were not popular before the New Kingdom. The most common type in the New Kingdom was a signet ring holding a scarab. During the New Kingdom, faience rings were mass-produced using moulds, vast numbers in the form of the *wedjat*.

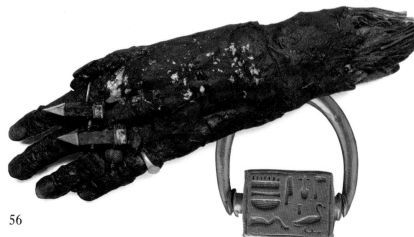

Stone sculpture

Ancient Egyptian sculptors and painters were not like artists of more recent times. They were artisans who worked according to instructions, often as part of a team, for example when preparing a tomb or temple wall.

In many ways stone sculpture and painting were crafts of death rather than life, being widely employed in tombs and for funerary objects. But stone sculpture was important also in temples and shrines, while painting was used for sculpture, furniture, walls of houses and pottery.

A block of stone – limestone, alabaster, basalt, quartzite, granite or sandstone – was extracted from a quarry using metal and stone tools for cutting slots into the rock. Wooden wedges placed in the slots were wetted and left to expand and split the rock into the required size.

Each face of the stone block was covered with a grid and an outline of the intended sculpture drawn in profile on the sides and full face at the front (plate 83). The stone was cut down using simple copper or bronze chisels and wooden mallets. Eventually, finer details were added and the surface polished with an abrasive stone (plates 84–6). The final stage was to paint the stone surface in plains of flat colour.

83 *Unfinished limestone statue of a queen. Work on the head has not progressed beyond the merest outline of the face and head-dress. The rest of the figure needed only a little further shaping before the final polishing of the surface. The angularity of the head betrays the squared grid from which the statue was cut. H: 51 cm. New Kingdom.*

84 *(Right) upper part of two diorite statues of the lion goddess Sekhmet from the temple of Mut at Karnak. The goddess was originally depicted on both with the sun-disk on her head and holding the sign of life (ankh) in her left hand. One of the statues was carved with the name of Giovanni Battista Belzoni, the former theatre strong-man and Capuchin monk who collected Egyptian antiquities in the early 19th century on behalf of foreign consuls. The statues, originally 206 cm and 196 cm in height, were broken into several pieces during the 1941 bombing of Liverpool Museum. 18th Dynasty, reign of Amenophis III.*

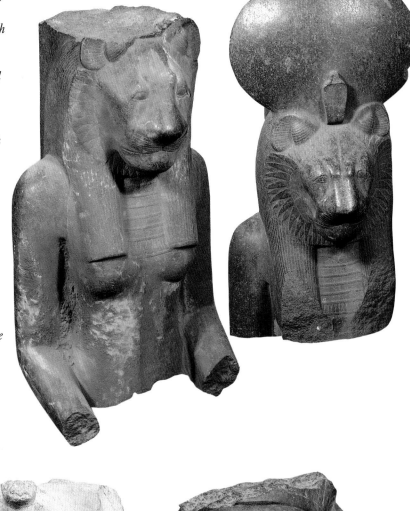

85 *(Below, left) limestone head of a king in Egyptian style, found at Tyre in Lebanon and apparently of local stone. Tyre was one of the Iron Age Phoenician city-states on the Lebanese coast. The Phoenicians adopted the New Kingdom style, by then several centuries old, for their own art. There were strong commercial ties between Egypt and Phoenicia and there may even have been some interchange between Phoenician and Egyptian artists and craftsmen. H: 21 cm. c.7th century BC.*

86 *(Far right) basalt head of a king wearing the nemes head-dress. H: 12.5 cm. Probably Late Dynastic Period.*

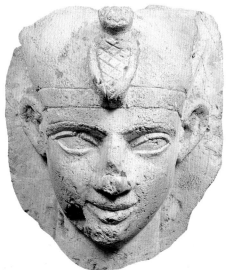

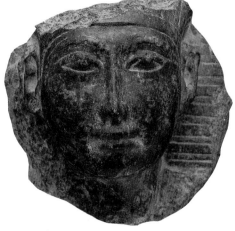

Relief sculptures are scenes cut into stone on tomb or temple walls, stelae or statues (plates 87–90). The scenes were first set out by the outline artist using a grid. The outline was then cut according to the type of relief to be used, raised or sunk. In raised relief the outline is cut and the surrounding stone cut down to form a flat background leaving the scene standing proud. Sunk relief reduces the stone inside the outline, leaving the background standing proud. Reliefs were always painted, and some small details were added in paint alone.

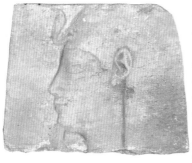

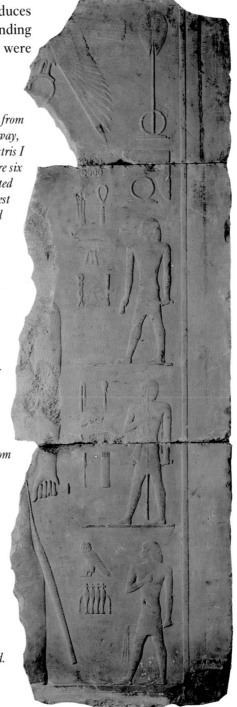

87 *(Above) limestone relief of a king, with traces of red paint on the face. This is probably a typical Ptolemaic sculptor's trial piece. H: 17 cm.*

88 *(Right) limestone fragments from a pylon, or ceremonial stone doorway, to part of the royal palace of Sesostris I at Memphis. Originally there were six scenes in raised relief which depicted stages in the investiture of the eldest son of the king as the royal heir and co-ruler with his father. Sesostris I was made co-regent in the 20th year of the reign of his father Amenemmes I. These blocks were later re-used as the filling for a moat. H: 198 cm. 12th Dynasty.*

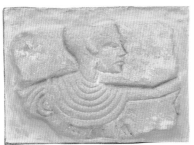

89 *(Left) sandstone sunk relief from Thebes of an official wearing a ceremonial collar, with remains of red paint on the face and body. The collar is probably the 'gold of valour', an award from the king for services rendered. W: 24.5 cm. 18th Dynasty.*

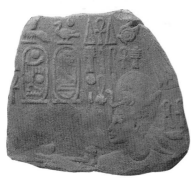

90 *(Left) sandstone raised relief with the head of Horemheb. Before him are his two names in cartouches, and above is a protective formula and the wings of the goddess Nekhbet. The king offers incense in a long-handled censer to a god. W: 23 cm. 18th Dynasty.*

Painting

Egyptian painters had a limited range of colours at their disposal. The basic shades were red, yellow, blue, green, black and white, which were mixed to produce oranges, browns, pinks and greys. These basic colours were derived from mineral pigments, and so have remained remarkably fresh over time.

Pigments were prepared by crushing them on a grinding palette with a stone pestle. When used for wall painting, an adhesive was needed, as the paint would not adhere to the plaster without a binding medium. A water-soluble gum was probably used.

Egyptian artists worked mostly in flat colours, though there were some experiments in shading. Because of the limited palette, conventions were developed for interpreting natural colours in terms of paint, for example green for vegetation, blue for water, yellow for gold. Male figures were reddish-brown, upper-class females were a paler brown or cream.

Large areas of paint were laid on with coarse brushes, made from bundles of palm fibres, or pieces of wood chewed or beaten at one end to separate the fibres into bristles. Separate brushes were kept for individual colours. Fine outlines were drawn with a narrow reed brush (plates 91–2).

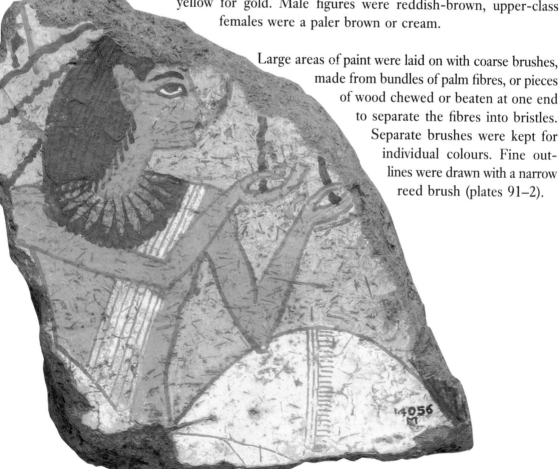

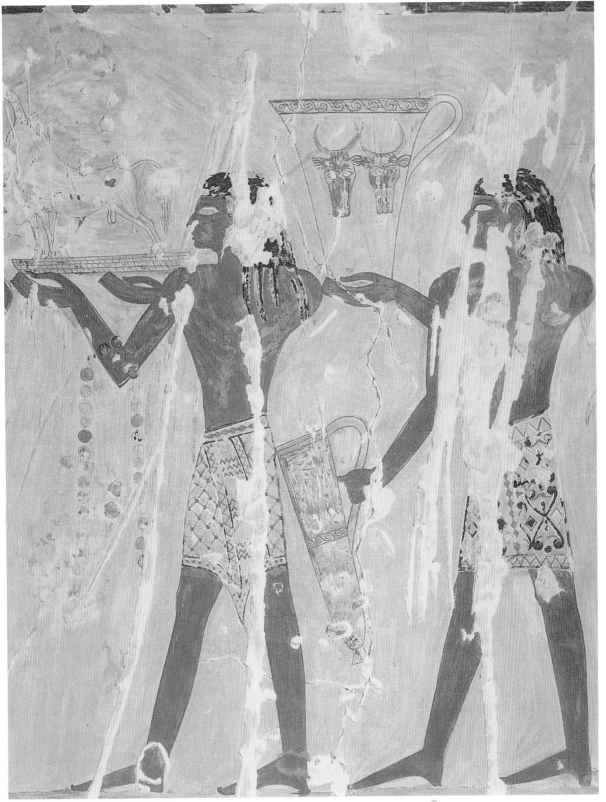

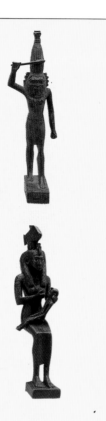

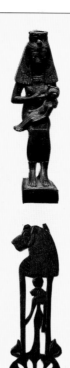

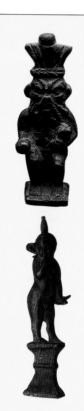

93　*Bronze figure of Amun-Re with a grotesque head with the mane and ears of a lion, holding an upraised mace. The head is that of Bes, the household god, and the conical reed cap, originally perhaps surmounted by a sun-disk, was worn by Amun. On the pedestal is a dedication by Nesptah, son of Unemuamun and Paneter. H: 20 cm. Graeco-Roman.*

94　*Seated bronze figure of the goddess Hatmehyt suckling Horus, a role normally associated with Isis. The name of the goddess means 'she who is in front of the fishes', and her chief cult centre was at Mendes in the Delta. She is sometimes depicted as the river barb fish. Fish were rarely used in ancient Egyptian iconography. H: 23.5 cm. 26th Dynasty to Ptolemaic.*

95　*Bronze figure of Isis seated with the child Horus on her knee. Her eyes and necklace are inlaid with gold. This touching image of mother and child may have inspired the later Christian icon of Madonna and Child. H: 21 cm. 26th Dynasty.*

96　*Bronze decorative* menat *(counterpoise). The* menat *was an important ritual object used by priestesses in temple ceremonies. It was suspended from a bead necklace and could be rattled to accompany singing and dancing. This one represents the lion goddess Sekhmet, her body depicted as a shrine. A figure of the goddess stands within, wearing a moon-disk. The name Sekhmet means 'the powerful'. She was the goddess of war and destruction, but was also regarded as a healer of illness. H: 15 cm. Late 18th Dynasty.*

97　*Bronze figure of Bes, holding a fish (?) in the left hand and a ball in the right. Despite his fearsome appearance, Bes was revered as the god of festivity. He is often seen playing musical instruments, and as a household god his fierce lion mask warded off evil from babies and pregnant women. H: 11.3 cm. 26th Dynasty.*

98　*Bronze appliqué of the infant Horus (Harpocrates). The god stands on a base (an altar?) wearing a small Double Crown of Upper and Lower Egypt and a sidelock denoting his youth. His fringe is bound in a knot and his right forefinger is held up to his mouth. H: 10.8 cm. Roman, late 1st–2nd centuries AD.*

The Gods

Hundreds of gods and goddesses were worshipped in ancient Egypt. Each region, city and village had its own particular god. Some of these rose in importance to become state gods with great temples dedicated to them. The gods of popular religion tended to be those concerned with the home and family. Other gods included deified humans and those absorbed into Egyptian religion from neighbouring cultures.

Unlike Greek and Roman religion, the Egyptians had no organised pantheon. Each god had a myth in which he was the most important player. As a result, there were several creation myths, each having a different god as the creator. Any contradictions in this did not appear to worry the Egyptians.

The gods could take three forms: human, animal or composite. They could also take on the form and functions of other gods. For example Isis, goddess 'great of magic', could be depicted wearing the disk and horns of the cow goddess Hathor. Both goddesses had mother functions and protected women and children.

Some gods were particular aspects of other gods. The supreme solar deity was Re, but in depictions of the sun's travel through the sky other solar deities appear. The god at dawn was Khepri, the scarab beetle rolling the sun between its forelegs; the god at dusk was Atum, 'the ancient one'.

In private religion the gods were associated with pregnancy and childbirth. Infant mortality was high and the old needed their children to look after them. These household gods had no major temples dedicated to them, but were worshipped in the form of amulets and small figurines.

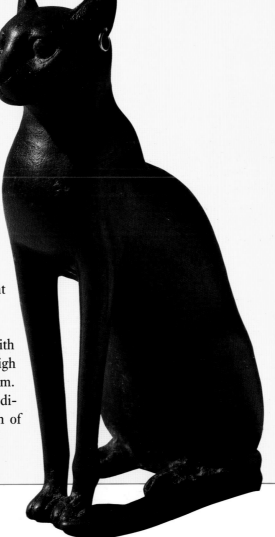

99 *Bronze figure of a cat, with pierced ears and one gold ear-ring. Bast was the cat goddess, worshipped at Bubastis in the Delta. Often associated with the lion goddess Sekhmet, she had the gentle nature of a mother and was goddess of fertility and festivity. She was also the daughter of the sun-god, Re. H: 15.5 cm. 26th Dynasty to Ptolemaic.*

Religious Ritual and Festivals

The Egyptian word for 'temple' is *hat-netcher*, literally 'God's House'. Temples were built for the major gods and used for daily ritual and festivals. The aim of state religion was to maintain *ma'at*, or the cosmic order, so a daily ritual was necessary to please the god. In theory, the king performed the ritual, but in practice it was the high priest of each temple. The daily ceremony was performed within the confines of the temple, to which the public was not admitted.

The daily ritual involved at least three visits to the god's innermost sanctuary by the officiating priest. The purpose was to make the cult statue attractive to the god, so that he would inhabit the statue and grant favours to the king. The daily ritual was performed in every sanctuary in every temple throughout Egypt at the same time.

The high priest had to be ritually and physically clean by bathing in the temple's sacred lake and shaving all body hair. Reciting ceremonial formulae, the priest opened the doors of the sanctuary at dawn. He took out the cult statue to clean it with water and natron. The cult figure was always dressed in fine clothes, jewellery and make-up, which had to be removed and replaced, and offerings of food, wine and incense made. The figure was returned to the sanctuary, the doors closed and bolted. At midday and evening a similar though shorter ritual was performed.

Festivals were religious ceremonies performed outside the temple walls in full public view. They were public holidays during which the priests took the cult statue from the sanctuary and paraded it in front of the people. The portable shrine of the god was taken from the sanctuary and placed on a ceremonial bark, borne on the shoulders of priests using lifting poles. Surrounding the sacred bark were priests and temple staff with ostrich-feather fans to waft it with cool air.

100 *The temple of Isis on the island of Philae at the turn of the century, partly submerged under the waters of the artificial lake created by the old dam at Aswan. The island used to be immersed in water for nine months of the year. With the building of the new High Dam at Aswan in the 1960s, the*

temple was moved and rebuilt on an island just south of the dam. The temple dates to the Graeco-Roman Period and has the characteristic plan of tall gateways (pylons), columned halls, and the sanctuary at the back.

The Egyptian calendar was made up of festival days. During the New Kingdom, the most important was the Festival of Opet when the sacred bark of Amun-Re at Karnak travelled to the temple of Amun at nearby Luxor. During the procession music was played and dancing performed as part of the ritual. Priests distributed food and drink to the people, creating an atmosphere much like a street party.

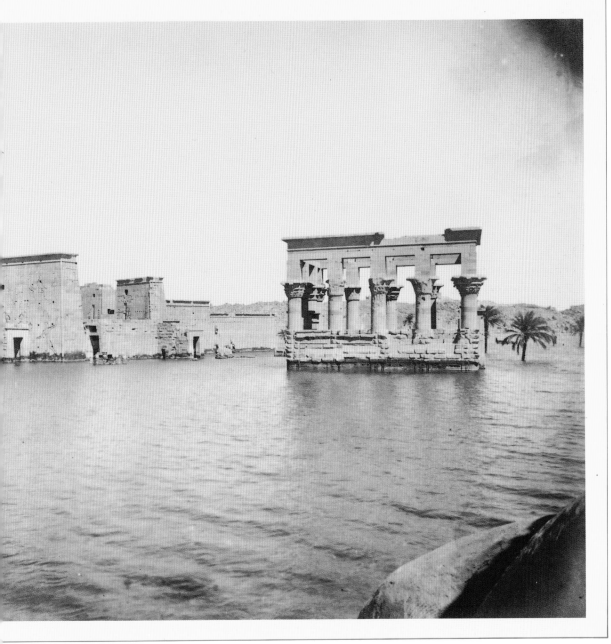

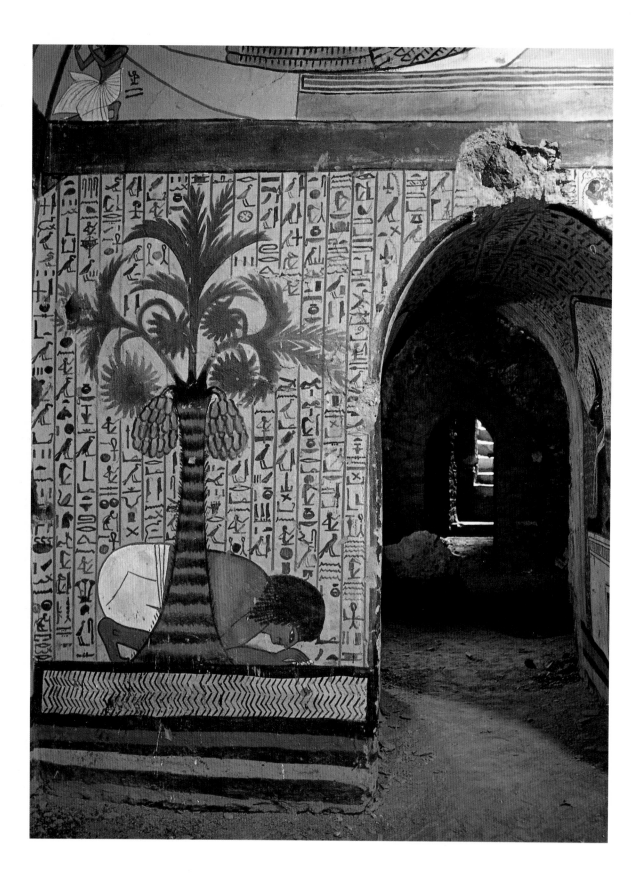

6
The Arts of Death

Ancient Egyptians and the afterlife

The afterlife was envisaged as a continuation of earthly life. Objects were placed in the tomb to ensure a continued existence at least equal to that on earth. The tomb was also equipped with a range of magic/religious items such as amulets, unguent containers, ceremonial emblems, ushabti figures and statuettes, as well as the coffin and canopic chest.

When someone died, the Egyptians believed that the body had to be preserved and placed in a tomb along with a supply of food and drink. Also necessary were a coffin or stela with the name of the dead man recorded on it to maintain his identity. Offerings were made at the tomb chapel and prayers said so that the soul could survive.

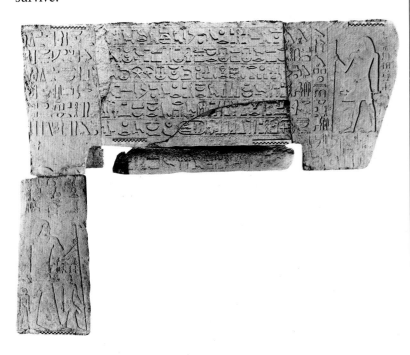

101 *(Opposite) the interior of the tomb of Pashedu, one of the builders of the royal tombs at Thebes. Pashedu is shown drinking from the sacred pool. Deir el-Medina, Thebes, 19th Dynasty.*

102 *Limestone fragment of doorway from the tomb of Ptahshepses at Saqqara. The deceased is represented twice, together with his son and daughter. The standard inscription prays that he will have a long life and a good burial (implying that the tomb was prepared while he was still alive), and names the feast days on which offerings are to be made to him at his tomb. Among his titles are High Priest of Ptah, and High Priest of the funerary city of Unas, last king of the 5th Dynasty, whose cartouche is on the bottom line of the main inscription. H: 169 cm. 5th Dynasty.*

103 (Below) head of a mummy, wearing a bead mask. The beads are of red, black, yellow and green faience, and at the sides are the remains of a network of long faience beads which once covered the neck. The mummy probably originally came from Abydos or Esna. H: 28.5 cm. 26th Dynasty.

104 (Bottom) mummy of a young woman, who was about 19 when she died. The head was modelled with resin to give it a realistic shape, and the eyes and mouth were painted. Each finger was bound separately, and the bandages about the feet were arranged in imitation of sandals. H: 160 cm. Roman Period.

Mummies and mummification

The origins of mummification go back to the Predynastic Period when the dead were buried in a contracted position in shallow graves in the hot, dry sand. The skin dried naturally, accidentally preserving the lifelike appearance of the corpse. Attempts to provide better security for the body by building proper tombs resulted in the decay of the tissues because they were no longer in contact with the sand. Artificial methods of preserving the body had therefore to be developed.

At first, mummification comprised little more than wrapping the body and limbs tightly in lengths of linen bandaging, probably in the misguided belief that covering the skin would prevent decay. Mummification was at its best during the late New Kingdom and Third Intermediate Period, when the means to preserve the body tissues had been perfected, as well as the skill of wrapping and coffining the finished mummy. Later, mummification reverted to the art of elaborate wrapping, culminating in individually wrapped fingers and toes and intricate patterns in the bandaging. Little attention was paid to preserving the tissues.

68

The following is a rough guide to the stages of mummification:

1 All soft internal organs were removed, except the heart and kidneys.

 a The brain was normally, but not always removed using a long metal hook through the nose or base of the skull, and then discarded.

 b The internal organs were taken out through a cut made in the left side of the abdomen.

2 The corpse and the body cavity were washed.

3 The internal organs were treated with natron, perfumed oils and resin.

4 The body cavity was packed with a temporary fill of natron to dry the inside, whilst dry natron was piled over the body. Desiccation took between 30 and 40 days to complete.

5 The abdominal cavity was packed with linen, moss or sawdust fragranced with spices.

6 The skin was washed with Nile water, symbolic of renewed life, and rubbed with oils.

7 The body was covered with resin.

8 The body was wrapped in layers of linen bandages.

The wrapping process was not continuous, but took place at specified times to the accompaniment of spells recited by a priest. Insects, lizards and mice have been found trapped between layers of bandaging, indicating that wrapping took place intermittently. After 70 days the mummy with its funerary mask and coffins was ready for burial.

In the Roman Period in Egypt the faces of mummies were painted as portraits in a naturalistic style. The majority of these portraits were painted in beeswax. The artists did not need to fuse the cold wax onto the surface of the panel by application of artificial heat. In the warm climate of Egypt it was possible to apply the wax in liquid form by means of a brush, a method called encaustic. From Petrie's excavations at Hawara comes a mummy of a young boy from the Roman Period (plate 105). In 13 layers an intricate diagonal diamond design was built up without the aid of stitching, pins or studs. Over the face is an inserted portrait of the boy in paint on a thin wooden board. X-rays have revealed the presence of two amulets, one placed on the tongue.

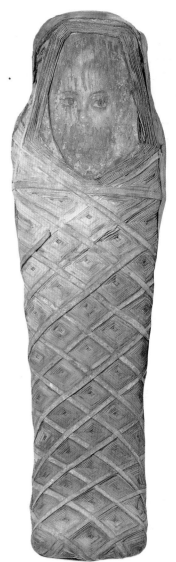

105 *Mummy of a young boy about two years old, from Flinders Petrie's excavations at Hawara. The bandaging is completely regular over the body and round the head and feet, and is the most perfect surviving example of the complex system of diagonal winding developed during the Roman Period. There are 13 layers of gilt, red, white, blue and brown linen bandages. A portrait of the boy painted on wood was inserted within the bandages over the face. H: 89.3 cm. Roman, c.1st–2nd centuries AD.*

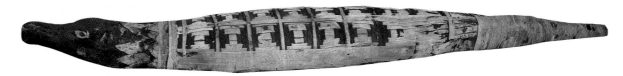

106 *(Top) mummy of a crocodile, with decorative bandaging. Crocodiles, like hippopotami, were common in ancient Egypt, but since the damming of the Nile in the south they are no longer found in the country. Crocodiles were sacred to the god Sobek and were buried in the Faiyum and at Kom Ombo, where their mummies can still be seen in the Graeco-Roman temple. L: 101 cm. Late Dynastic Period.*

107 *(Right) mummy of a cat, with decorative bandaging. The head has been modelled and painted to resemble a cat. Some cats were mummified in a crouched position and placed inside a cat-shaped coffin. The cat cult, in honour of the cat goddess Bast, was particularly popular in the Late Dynastic Period. Cats were specially bred for sacrifice and mummification by pilgrims. In the 5th century BC, the Greek historian Herodotus wrote that at Bubastis, the cult centre of Bast, all the people in a house 'where a cat has died a natural death shave their eyebrows'. The 1st-century BC Greek historian, Diodorus Siculus, reports that he saw a Roman lynched in Egypt for accidentally killing a cat. L: 41 cm. Late Dynastic Period.*

Animals were also mummified (plates 106–7). Each god was identified with some animal and embodied its attributes. One way of attracting the favour of a god was to make an offering, in mummy form, of an animal sacred to the god. The whole range of animals known from ancient Egypt has been found mummified and packed into underground complexes, especially from the Graeco-Roman Period. At Tuna el-Gebel, the cemetery dedicated to Thoth, the number of mummified ibises is estimated at over four million.

It is likely that animals were bought specially for an offering, killed, then taken to a workshop for mummification. The quality of the wrapping depended on the amount paid. In the Late Dynastic Period, bandaging was at its most elaborate. Animals were wrapped in linen of different colours often forming diamond patterns. Occasionally the features of the animal were painted on the head.

The decline in human and animal mummification coincided with the spread of Christianity in the 3rd century AD. By the 4th century AD bodies were interred in old clothes or wrapped in old wall hangings. Sometimes a small pillow was placed below the head with the body supported on a wooden board.

Coffins and sarcophagi

In the Predynastic Period, the dead were buried in a contracted position facing the west, towards the setting sun and the place of the afterlife. Some burials were in reed matting or animal skins, and later in baskets and large pots.

In the 2nd and 3rd Dynasties, wooden coffins appeared. These were rectangular and short, because the bodies were still contracted. They faced the east, towards the rising sun as the symbol of resurrection.

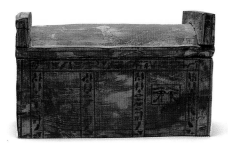

108 *Miniature wooden coffin with vaulted lid of Nemtyemweskhet, the seal bearer of the king and high steward, from Abydos. Apart from the inscription, the only decoration is a tiny eye panel within a rectangular frame. Originally the coffin contained a ushabti, and acted as a dummy burial with a substitute body which enabled the deceased to take part in the afterlife. He was an important official, responsible for the provisioning of the king's residence. The shape of the miniature coffin exactly copies full-sized coffins of the time. L: 29.2 cm. 13th Dynasty.*

During the 4th Dynasty for the first time the internal organs of the dead were removed during mummification, and the bodies could be laid out flat. Consequently coffins became full length, made of small pieces of local wood dowelled together like a jigsaw. Imported cedar wood allowed coffins to be made from straight planks.

Coffins served two purposes: to protect the body from robbers and to provide magical protection through texts and shape. There were two types of coffin: the rectangular box coffin and the mummy-shaped anthropoid coffin. The earliest box coffins represented the house of the mummy through the recessed panelling on the sides. During the Middle Kingdom the texts on the box associated the coffin with the underworld of Osiris.

In the Old and Middle Kingdoms, the deceased was placed on his left side in the coffin, facing east and the part of the tomb where the offerings were made. In order to allow the deceased to 'see' out of the coffin, a pair of eyes was painted or carved on the exterior head end (plates 108–9). From the 17th Dynasty on, the deceased was laid on his back, and this became the normal method of burial.

109 *Wooden coffin of Nakht from Beni Hasan. The coffin was intended to represent the house of the spirit of the deceased. The colourful decoration gives some idea of the appearance of a house of the period, its mud-brick walls hung with painted mats. Eyes in the side near the head allowed the spirit to 'see' out and doors painted on the head end allowed it to exit in order to partake of the offerings left next to the coffin. L: 207 cm. 12th Dynasty.*

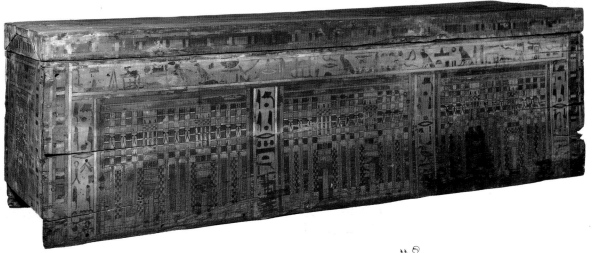

110 *Painted cartonnage mummy case made for a woman, from Tarkhan. L: 170 cm. 23rd–25th Dynasties.*

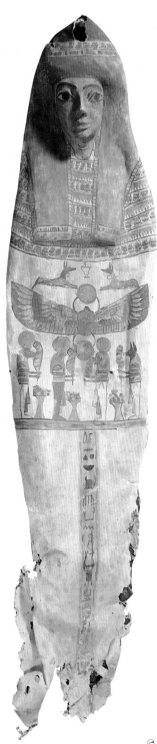

The anthropoid coffin developed out of the mummy shape of First Intermediate Period and early Middle Kingdom bodies, with their lifelike masks placed over the head. Anthropoid coffins magically served as a substitute body where the deceased's spirit could reside should the real body be destroyed. The coffin could be made of carved wood or of cartonnage, a mixture of linen and plaster (plates 110, 112–13). During the New Kingdom, the anthropoid shape was associated with the mummiform body of Osiris, and was made with the arms crossed on the chest, a long Osirian beard, and green or black skin.

Sarcophagi, or outer coffins made from stone such as quartzite, limestone, alabaster and granite, tended to be reserved for royalty and high officials (plate 111). Already in the Old Kingdom the highest ranking courtiers had a stone sarcophagus and one or two wooden coffins. New Kingdom kings were buried in huge stone sarcophagi which held up to three anthropoid coffins, the complete surviving set of Tutankhamun being the best example.

111 *(Below) granite sarcophagus of Bakenkhonsu, First High Priest of Amun under Ramesses II, found in his tomb at Thebes. On the sides are relief scenes of Thoth holding a standard bearing a star, and the four sons of Horus. Events in Bakenkhonsu's life are recorded on a statue now in Munich, including the building of a temple on behalf of Ramesses at Karnak. As First High Priest of Amun he was one of the most influential officials in Egypt. The sarcophagus was destroyed during the Second World War, but has now been rebuilt with some restoration. This picture shows it complete before the war. L: 220 cm. 19th Dynasty.*

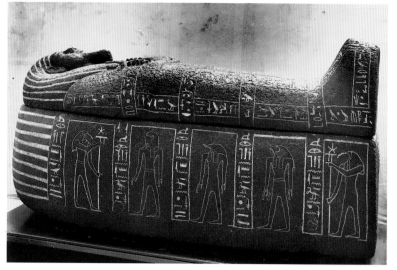

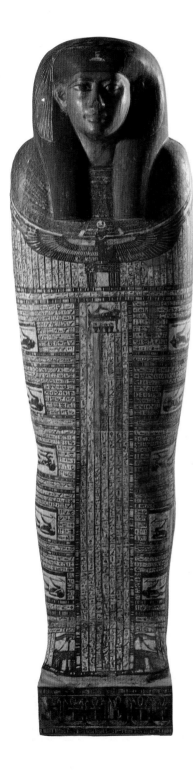

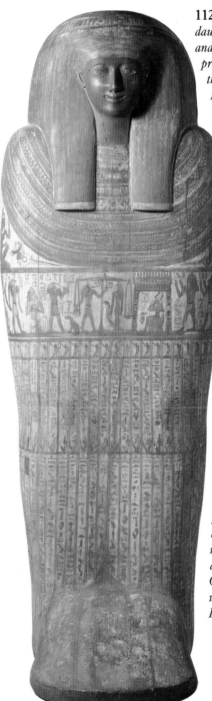

112 *(Left) coffin of Ditamunpaseneb, daughter of Yufa, a priest of Amun, and wife of Namenkhamun, a lector-priest of Amun, from Thebes. Most of the inscriptions are extracts from the Book of the Dead. The sky goddess Nut protects the deceased with her outstretched wings, and below is a scene showing the mummy on its funerary bier with the four canopic jars beneath. L: 173 cm. Late Dynastic Period.*

113 *(Right) outer coffin of Pedeamun, sailor of the bark (boat) of Amun, chief of navigation of the bark of Amun, son of Thatienwenzu and Tadetanebthenen. The central scene is the weighing of the heart of the deceased before Osiris. On the shoulders are unusual depictions of the hippocampus (seahorse). The coffin and its mummy were seen in Thebes in 1826 and brought to England. In 1851 the coffin was opened and the mummy unwrapped by an eminent Gloucester surgeon. Such mummy-opening events were great social occasions in the 19th century, and this one was reported in the local press, the audience afterwards being entertained by the Cirencester Band and provided with refreshments. L: 219 cm. Late Dynastic Period.*

Canopics

Canopic chests and jars were the vessels which held the internal organs removed during mummification – the liver, lungs, stomach and intestines (plates 114–15, 161). Four jars were needed or a box divided into four compartments. Each jar was associated with one of the four sons of Horus, protective deities identified with the internal organs. The liver was identified with Imseti, the lungs with Hapy, the stomach with Duamutef and the intestines with Qebehsenuf. These gods were in turn associated with protective goddesses whose names frequently appear in the text bands on the jars and boxes. They are Isis, Nephthys, Neith and Serket respectively.

The jars holding the internal organs could be of pottery, wood, stone, faience or cartonnage. At first the lids were formed like human heads, often of painted wood. By the end of the 18th Dynasty the canopic lids were fashioned in the form of the protective deities they represented: a human head for Imseti, a baboon head for Hapy, a jackal head for Duamutef and a hawk head for Qebehsenuf.

114 *Set of alabaster canopic jars to hold the internal organs of the deceased, with lids in the form of the four sons of Horus: (left to right) Duamutef (jackal = stomach), Hapy (baboon = lungs), Imseti (human = liver) and Qebehsenuf (hawk = intestines). This set was inscribed for Wahhor, son of Ptahhotep. Average H: 36 cm. Late Dynastic Period.*

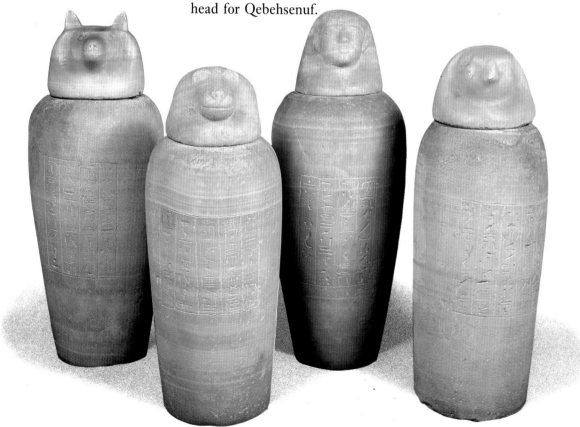

Middle Kingdom canopics usually comprised a wooden box decorated with bands of text to match the coffin. This box was either placed in a niche in the floor or wall, or in a stone chest. The interior of the wooden box was frequently divided into four compartments to hold the four jars.

From the 21st Dynasty, the mummified internal organs were returned to the body cavity accompanied by small wax statuettes of the four sons of Horus. Since it had become customary to provide canopic jars and boxes, real or dummy ones were placed in the tomb until the Ptolemaic Period.

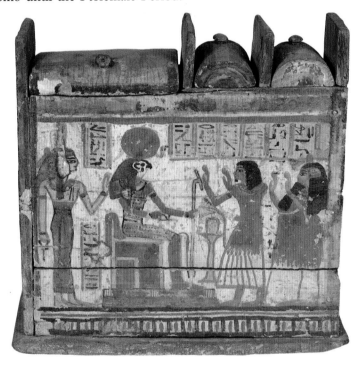

115 *Painted wooden canopic chest of Khennem, an official with the title Overseer of Followers. The deceased and his wife are shown worshipping the gods: Re-Harakhte and Ma'at on one side (seen here) and Osiris and Isis on the other. H: 36 cm. New Kingdom?*

Ka figures and ushabtis

The Egyptians believed that the *ka* was the life force present within every person from birth. During the Old Kingdom a statue of the tomb owner was placed in the *serdab*, a small enclosed room within the tomb with 'windows' for the statue to 'see' out. The *serdab* was sometimes referred to by the Egyptians as 'the house of the *ka*', and so the term '*ka* statue' is often applied to such figures (plate 119). Their purpose was to allow the soul of the tomb owner to enter the offering room and partake of the offerings, to benefit from the carved and painted scenes on the tomb walls, and to act as a substitute body should the real one be destroyed.

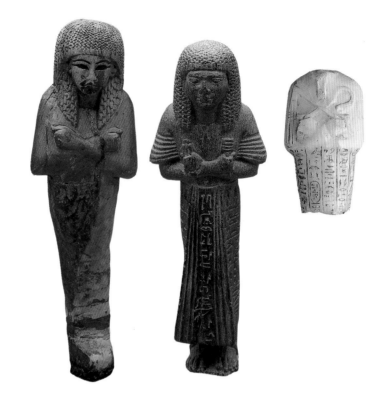

116 *(Left) wooden ushabti with very fine zigzagged wig and layered lappets. The eyes and brows are recessed for inlay (part of the gold inlay survives in the right eye). The ear-lobes are pierced. The hands are clenched across the chest and there are faint traces of an inscription below. The lower part of this ushabti has been restored. The layering and fine detail of the wig are characteristic of the late 18th Dynasty. H: 19.5 cm.*

117 *(Centre) steatite ushabti with a rippled wig. The kilt is gathered into a long pleated panel, with an inscription on the front. Wearing the clothes of the living, such ushabtis are identified as the overseers of gangs of workers represented by mummiform ushabtis. Further distinctions can include the presence of a whip to encourage the workers. H: 16 cm. 19th–20th Dynasties.*

118 *(Right) fragment of alabaster ushabti of Amenophis III. The reign of Amenophis III was the great age of the ushabti, in terms of numbers, quality and materials. The king had more than 60 ushabtis made for his burial in different stones, wood and faience. In this one, he stands in the form of a mummy, holding his and Osiris' symbols of authority, the crook and flail, across his chest. From other examples, we know that the king's head would have worn the Double Crown of Upper and Lower Egypt or the* nemes *head-dress. The inscription is incised and picked out in blue, and was a version of the ushabti text specially written for Amenophis III. H: 10.5 cm. 18th Dynasty.*

Ushabti figures, first found in the Middle Kingdom, were substitutes for the dead person, to do the work required of him in the afterlife (plates 116–18, 120–1). Their mummiform shape recalls the body of the deceased. Agricultural and construction labour was compulsory for all Egyptians except the official classes, but in life those who could afford it exempted themselves by nominating a servant as a substitute. In death, a ushabti would be used for the same purpose of avoiding work, and from the 18th Dynasty ushabtis were often equipped with small hoes and baskets. The formula written on ushabtis is a spell which reads:

X says, 'O ushabti! If X is detailed for any tasks to be performed there [in the afterlife], as a man is bound to do, namely to cultivate the fields, to flood the banks and carry away sand to the east and to the west, then say you "Here I am".'

Middle Kingdom ushabtis were usually provided singly. By the 19th Dynasty one ushabti was provided for each day of the year, 365 in all. The magical nature of the figures and the work they undertook led to the creation of overseer ushabtis. The gang of 365 was roughly divided into ten gangs, each organised by an overseer ushabti, totalling 401 figures per tomb.

76

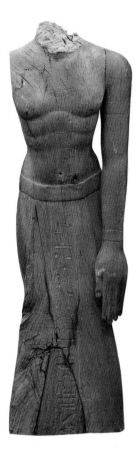

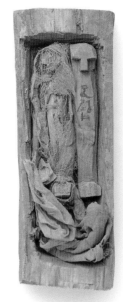

119 *(Left) wooden* ka-*figure of Ta-iri, a lector-priest. His name and titles are carved on the vertical panel formed by the stiffened folds of his kilt. The figure is particularly well carved on the torso. The rolls of fat below the chest indicate that this was a man of means, able to eat to excess. Corpulence, even discreet examples like this, was an indication of social standing. H: 40 cm. New Kingdom.*

120 *(Right) coarse model wooden coffin with two wooden ushabtis wrapped in linen and inscribed in ink, from Esna. Roughly shaped coffins like this with crude figures are typical of Second Intermediate Period ushabtis. L: 24 cm. 17th Dynasty.*

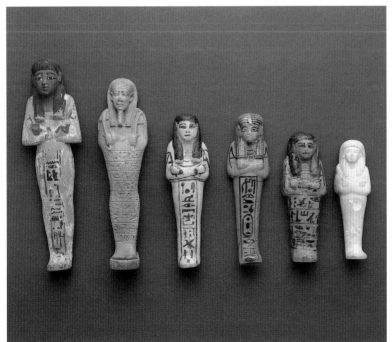

121 *Ushabtis of faience, wood and limestone, dating from the 19th to the 26th Dynasties. The third from the right has the cartouche of Pinodjem I of the 21st Dynasty. Note the agricultural hoes and rope basket handles grasped in their hands. H (left): 19.5 cm.*

Amulets

The dead as well as the living relied on the sympathetic magic of amulets for general or specific protection (plates 123–4). General protection could be afforded by such amulets as the *ankh* or sign of life, by the *djed*-pillar or symbol of stability, and by small figures of gods. Some amulets were designed to protect certain parts of the body, or could confer the power inherent in them to the dead, like the amulet in the form of the royal crown. An amulet in the form of a head-rest protected the head from being separated from the body. A snake's-head amulet could protect against snake bites.

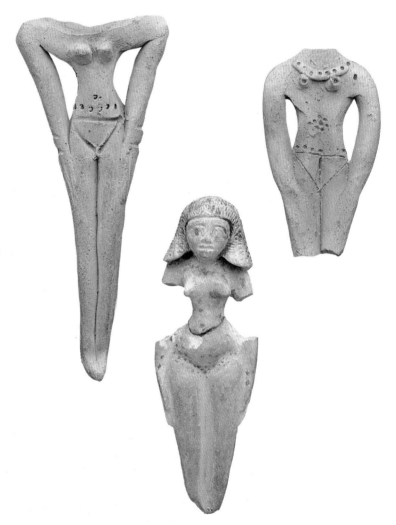

122 *(Above) faience amulets of the four sons of Horus who protected the internal organs of the deceased: Imseti (human), Duamutef (jackal), Qebehsenuf (hawk) and Hapy (baboon). H (left): 4.6 cm. 26th Dynasty.*

123 *(Right) terracotta and limestone female figurines from Esna with tattoo marks indicated. The emphasis on the features of the body, and the lack of interest in details of head and legs, suggests that they were intended to promote fertility for both living and dead alike. H (left): 13 cm. Middle Kingdom to Second Intermediate Period.*

124 *(Opposite) group of 32 amulets made of semi-precious stones, taken from the mummy of a man. Most were lying on the breast of the mummy, but the two largest lay within the abdominal cavity. H (bottom left): 5.1 cm. Ptolemaic.*

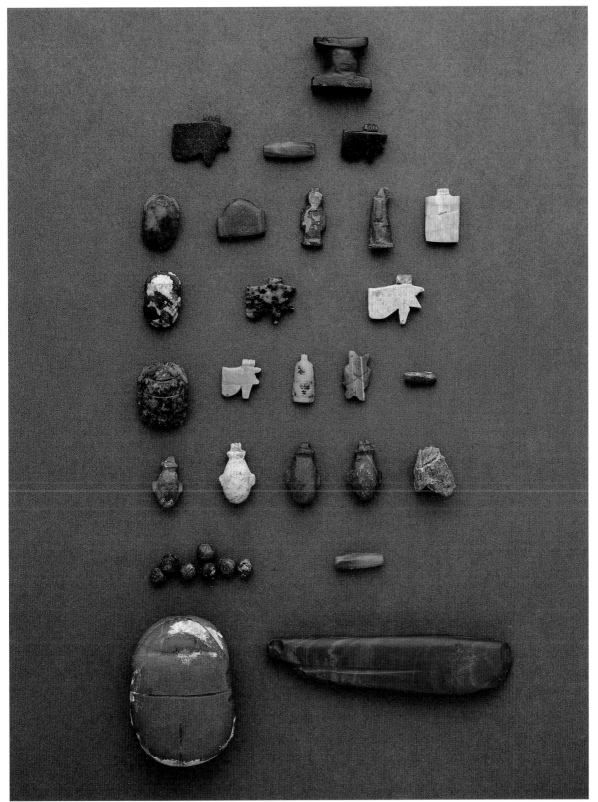

79

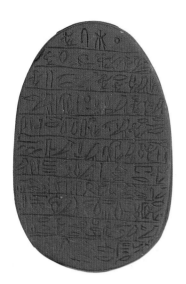

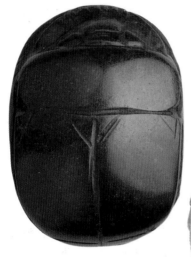

From the New Kingdom on amulets were regularly placed within the mummy bandages. The most important of these was the heart scarab (plate 125). The Egyptians believed that the heart was the seat of thought and personality, and left it in the mummified body so that it could be weighed at the 'judgement' against the feather of Ma'at, the goddess of truth. To ensure that the heart was not heavier, a spell was needed, written on the base of a heart scarab. These were usually placed near the heart or generally on the chest.

Offering trays, soul houses and models

As part of the cult of the dead it was the duty of the family, usually the eldest son, to make offerings at the tomb as *ka*-priests. The offerings comprised specially made loaves and jars of beer. Offering trays contained models of loaves, onions, cucumbers and meat as a magical substitute for real offerings, together with water channels for libations (plate 126).

127 *(Below) aragonite tablet with seven circular depressions, with the names of seven sacred oils used in funerary ceremonies. These oils were standardised, and the same ones, largely derived from plants, had been used since Old Kingdom times. The god of the sacred oils was Nefertum, who was also god of the primeval lotus blossom, regarded as the fragrant lotus blossom in front of the nose of Re. L: 12 cm. New Kingdom.*

125 *(Above) two serpentine heart scarabs, one with part of the Book of the Dead inscribed for Ramose. The prayer asks the heart not to betray the deceased at the 'weighing of the heart', thus condemning him to eternal annihilation. L: 5.5 cm, 5.6 cm. 19th Dynasty.*

126 *(Above, right) pottery offering tray with a bench, water jar, a stylised ox (in the centre) for meat, and bread. Placed near the mouth of the tomb, these trays magically provided all the offerings modelled on their surfaces. D: 25 cm. Middle Kingdom.*

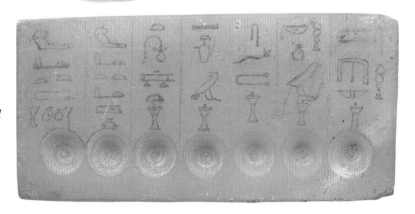

80

Soul houses took the form of a house or hut, and may have served as dwellings for the soul or as a substitute for tomb chapels (plate 128).

Many tomb paintings were concerned with the provisioning of the tomb. A particular fashion during the First Intermediate Period and the Middle Kingdom was to substitute crude wooden servant models for tomb paintings (plates 129–30). These models depict men and women making bread and beer, slaughtering oxen (plate 17), and girls bringing ducks and pigeons and baskets of food or beer on their heads. Other models depicted boats and workshops for carpenters, weavers or potters.

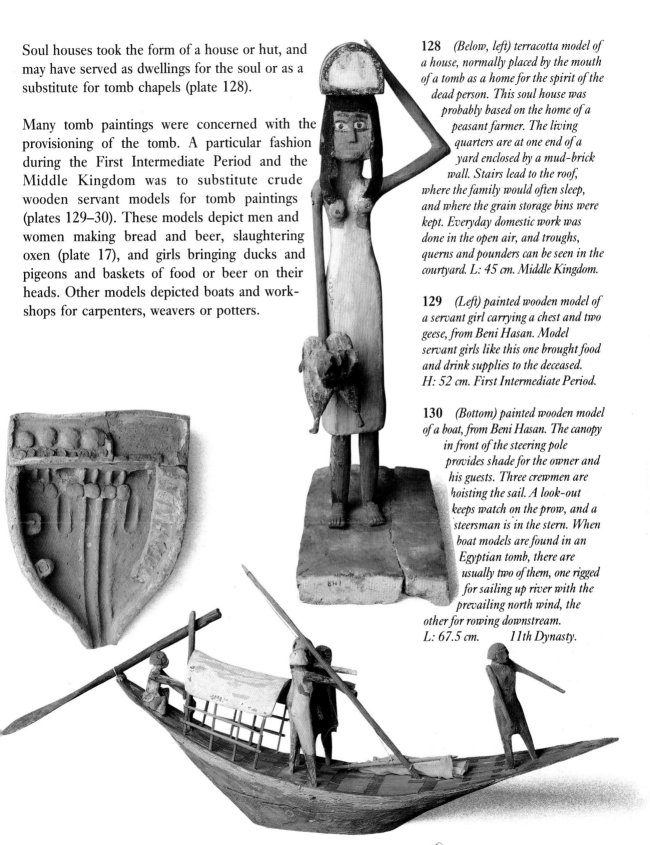

128 *(Below, left) terracotta model of a house, normally placed by the mouth of a tomb as a home for the spirit of the dead person. This soul house was probably based on the home of a peasant farmer. The living quarters are at one end of a yard enclosed by a mud-brick wall. Stairs lead to the roof, where the family would often sleep, and where the grain storage bins were kept. Everyday domestic work was done in the open air, and troughs, querns and pounders can be seen in the courtyard. L: 45 cm. Middle Kingdom.*

129 *(Left) painted wooden model of a servant girl carrying a chest and two geese, from Beni Hasan. Model servant girls like this one brought food and drink supplies to the deceased. H: 52 cm. First Intermediate Period.*

130 *(Bottom) painted wooden model of a boat, from Beni Hasan. The canopy in front of the steering pole provides shade for the owner and his guests. Three crewmen are hoisting the sail. A look-out keeps watch on the prow, and a steersman is in the stern. When boat models are found in an Egyptian tomb, there are usually two of them, one rigged for sailing up river with the prevailing north wind, the other for rowing downstream. L: 67.5 cm. 11th Dynasty.*

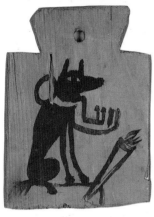

Stelae

Stelae or commemorative stones were a very important part of the tomb equipment (plates 131–6). They could be made of stone or wood, and were inscribed with the name and titles of the tomb owner. The owner is depicted either seated before an offering table piled high with various types of food and drink, or offering to gods. There may also be a written offering list. The text on stelae includes a funerary prayer or offering formula which reads basically: 'A boon which the king gives to Osiris that he may give an invocation offering of bread, beer, oxen, fowl, alabaster, clothes and all things good and pure on which a god lives, to the *ka* of X'.

131 *(Above) in the Graeco-Roman Period, inscribed wooden labels were attached to mummies as a form of identification and to take the place of a stela. These examples are inscribed with Greek names, one of a 12-year-old child, and a drawing of a funerary scene showing Anubis with a key round his neck and a burning torch in front. H (Anubis): 15.5 cm. 2nd–3rd centuries AD.*

132 *(Right) granite stela, carved in sunk relief, of Khnumu, who is shown with two other members of his family. H: 95 cm. 12th Dynasty.*

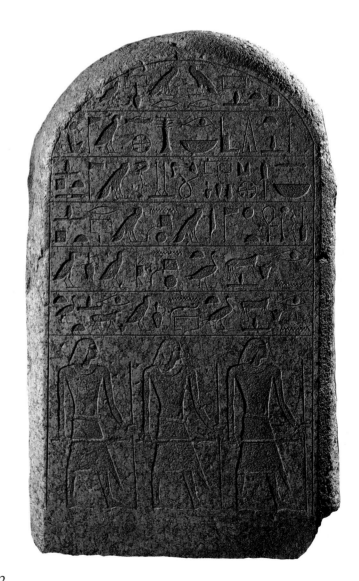

82

Stelae were usually set up in the superstructure chapel of the tomb or at the mouth of the shaft, in a place accessible to the living. An altar in front received the offerings and libations left by family members and the *ka*-priests at specific times.

Some stelae were erected in household shrines or were dedicated in temples. These may depict figures of gods with rows of ears behind them in the hope that the gods would hear the prayer.

133 *(Top left) limestone panel from a false door at the Saqqara tomb of Nyankhtety, Controller of Scribes at the Royal Palace, showing in raised relief the deceased seated before an offering table piled with loaves of bread and joints of meat. H: 61 cm. 4th Dynasty.*

134 *(Top right) painted wooden stela of a lady before the god Re-Harakhte, with a border formed of the body of the sky goddess Nut stretched over them. Within her body are the stars. At dusk she swallowed the sun and gave birth to it at each dawn, symbolising the daily cycle of day and night. H: 29.7 cm. New Kingdom to Late Dynastic Period.*

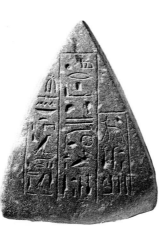

135 *(Bottom left) painted limestone stela in sunk relief of the priest Mentuhotep. The main panel shows Mentuhotep sniffing a lotus flower while seated on a chair with lion legs, before a table of offerings containing an ox head and leg, bread, fruit and vegetables. Under the table are two wine jars, one still sealed. The lower two panels show Mentuhotep and his relatives. H: 45.6 cm. 12th Dynasty.*

136 *(Bottom right) granite pyramidion in sunk relief of the vizier Neferronpet. Originally this must have capped a small brick pyramid like those found on free-standing tomb chapels in the New Kingdom cemetery at Saqqara. H: 41.5 cm. 19th or 20th Dynasty.*

Pyramids and Royal Tombs

The Egyptians buried their dead on the edge of the desert. Here it was dry and relatively safe, which is why burials and tombs feature so prominently in Egyptian archaeology. The preservation of the body did not stop at mummification or at the elaborate spells designed to protect it. The construction and security of a tomb was just as important, and it had to last for all eternity if everlasting paradise was to be enjoyed.

The first known royal tombs were of the mastaba (bench-shaped) type at Saqqara and Abydos. In rows around the Abydos tombs were smaller subsidiary tombs of servants and relatives who appear to have been buried at the same time as the king.

The most spectacular of 3rd-Dynasty royal tombs is the Step Pyramid of King Zoser at Saqqara. Built entirely of stone, it did not start out as a pyramid, but as a massive square mastaba which underwent two stages of extensions until the plan was altered to the pyramid design. Originally the pyramid had four large steps, but was itself enlarged to a six-step structure. The pyramid is part of a huge complex enclosed by a wall, containing a series of courts and dummy buildings connected with the ceremonies of kingship. Other kings of the 3rd Dynasty built stepped pyramids but these were never completed.

Seneferu of the 4th Dynasty filled in the steps with horizontal courses to make the first straight-sided pyramid. He built two pyramids of his own at Dahshur. The earliest of these is the 'Bent' pyramid, so called because the angle of incline alters about half-way up. The other pyramid is the first true pyramid, with an angle of incline of 43°36'.

The pyramids of Cheops, Chephren and Mycerinus at Giza are the most famous because of their size. The largest, of Cheops, stood at over 146 m high with each of its massive blocks weighing 2.5 tonnes (plates 23–4). The Sphinx at Giza is associated with Chephren next to whose valley temple it sits. It was carved from a solid knoll of rock left over from quarrying for the king's pyramid.

The shape of the true pyramid was probably influenced by the shape of the mound of creation in the mythology of the solar cult at Heliopolis, which was at its height during the 4th Dynasty. Smaller and less accomplished pyramids were built by the kings of the 5th and 6th Dynasties at Abusir and Saqqara.

Kings of the 11th Dynasty were buried at their capital, Thebes. Nebhepetre Mentuhotep II's tomb at Deir el-Bahri had several

137 The three pyramids of Cheops, Chephren and Mycerinus at Giza in the late 19th century, showing how far the flood plain of the Nile may have reached in ancient times. Today, with the level of the Nile controlled by the Aswan High Dam, the course of the river runs far away from the pyramids.

terraces with porticoes shading carved and painted reliefs. It was surmounted by what is now believed to be a dummy mastaba, with the real burial chamber deep within the cliff.

The 12th-Dynasty kings returned to Old Kingdom traditions and built their tombs as pyramids. These were more economic structures utilising small stone facings, rubble and sand-filled interiors and mud brick.

The 18th Dynasty saw a radical break with tradition. It was realised that a pyramid attracted rather than deterred robbers. The tomb needed to be hidden, and so a secluded valley on the west bank at Thebes was found. The first tomb to be cut deep into the rock in the Valley of the Kings was that of Tuthmosis I. Early 18th-Dynasty royal tombs had a right-angle turn and a deep shaft designed to fool robbers and catch water from occasional flash floods. Later tombs were straight with corridors and pillared halls decorated with scenes of the king before the gods of the underworld and funerary texts. The craftsmen working on the royal tombs combined their resources to build and decorate their own tombs in a similar though less grandiose style (plate 101).

Late Dynastic Period royal tombs are mostly yet to be found. Some 21st and 22nd-Dynasty royal tombs have been found at Tanis in the Delta. The tombs are modest semi-subterranean rooms without decoration within the precincts of the temple of Amun.

Pyramids were built by the Nubian kings of the 25th Dynasty from Napata. These structures are relatively small, some 12 m square, and have very steep sides. The later Meroitic kings also built steep-sided pyramids at their capital, Meroe (plate 145).

7
Christian Egypt

The Copts

The word 'Copt' was used by the Muslim invaders of AD 640 to describe the Christian inhabitants of Egypt. It is an Arabic corruption of the Greek word *Aigyptos*, which meant 'Egyptian' but had no specific religious connotation. The description 'Coptic' is now extended to the language and art of Egyptian Christians.

Christianity came to Egypt from Palestine probably in the mid-1st century AD. At that time Egypt was under Roman rule, and Christians were often persecuted for refusing to worship the emperor. The early Christians left detailed written accounts of their dreadful suffering at the hands of Roman officials. The more Christians were persecuted, the more popular their religion became, and Christianity had become the majority religion in Egypt by about AD 325. Copts still make up almost a tenth of Egypt's population today.

138 *Papyrus prepared by the notorious forger Constantine Simonides (1824–1867), claimed to be fragments of the Greek text of the Gospel of Matthew, allegedly written by Nicolaus the Deacon at the dictation of Matthew in the fifteenth year after the Ascension. This and other forgeries were uncovered by a special committee of the Royal Society of Literature in 1863.*

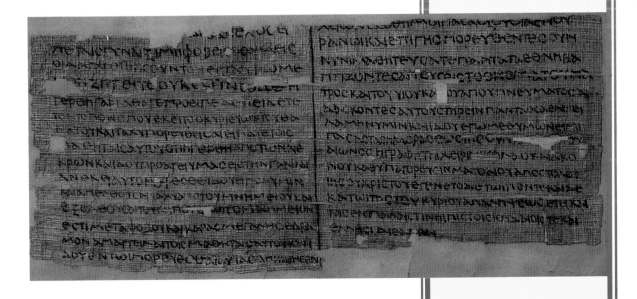

Christianity and the monasteries

The church at Alexandria was founded by the evangelist Mark, according to a 4th-century AD tradition. Christianity in Egypt emerged as an important force in AD 180 with the foundation of the catechetical school in Alexandria. This school produced two of the greatest Christian scholars, Clement (c.AD 160–215) and Origen (c.AD 185–251). Their work was the first attempt to rationalise Christianity within the framework of Hellenistic philosophy.

Christianity had spread from Alexandria to the rest of Egypt probably by the 2nd century AD, but there was a radical break in burial customs only in the 4th century AD. The ancient Egyptian tradition of mummification and belief in Osiris was abandoned. The body was now dressed in daily clothes and buried in a simple grave, resting on a wooden board or directly on the sand.

The great legacy of Coptic Egypt is the development of Christian monasticism. Individuals sought refuge and solitude at the edges of the desert because of religious persecution, especially by the Roman emperors Decius (AD 249–251) and Diocletian (AD 284–305), and the heavy burden of taxation. Egypt's warm climate made endurance of hardship somewhat easier. In western tradition Paul is regarded as the first solitary Christian hermit. According to St Jerome, Paul retreated to the desert at the age of 16 to escape persecution. However, this tradition is suspect and it is certain that monasticism was wholly of native Egyptian origin.

The true founder of Egyptian monasticism was Antony (c.AD 251–356). He became a hermit after hearing the passage in the Gospel of Matthew in which Jesus tells a young man to sell all and follow him. Antony at first lived in a deserted fort. Bread was brought to him twice a year, and his only water was seeping moisture. Eventually his fame attracted disciples who joined him and a common way of life was established. There was some degree of formal organisation, but no written rule or constitution. Indeed, the monks often lived some distance from one another.

Monasticism as communal life regulated by rule originated with Pachomius in the early 4th century AD. He established a community near Akhmim in which the monks' daily life was regulated in every detail by a formal written rule. All Christian monasticism stems from these Egyptian origins. By the 4th century in Egypt,

there were many thousands of monks, who formed a significant part of the whole population.

In the 3rd and 4th centuries, the Christian Church was dominated by the problem of heresy. The patriarch of Alexandria was in constant conflict with the Byzantine authorities, and the monasteries were fanatically loyal to him. At the Council of Chalcedon in AD 451, the Egyptian Church was condemned for heretical opinions – it adhered to the Monophysite doctrine that in the person of Christ there was only one divine nature. The influence of the Coptic Church on Christianity declined after this schism. Within Egypt, it continued to flourish for some time after the Arab conquest.

139 *Ivory panel showing a winged running youth carrying a hare. The youth is to be identified as October, the month of the grape harvest. The hare was regarded as the traditional enemy of a vineyard. This type of panel would have been mounted on a wooden casket. H: 17 cm. Coptic, probably 4th century AD.*

The Coptic language

Coptic is the best understood phase of the ancient Egyptian language. The script used the Greek alphabet with the addition of seven signs derived from demotic for sounds not present in Greek. It is a purely alphabetical script, unlike hieroglyphic, and so accurately reflects the actual sounds of speech. Coptic originated in the Roman Period to indicate more precisely the correct pronunciation of words. It developed with the need for translations of the scriptures into the vernacular. The Coptic literature that has survived is mostly religious, with biblical manuscripts predominant, including heretical Gnostic and Manichaean texts.

After the Muslim conquest, Arabic gradually became the main language. Coptic had probably ceased to be spoken by the 16th century although it has continued to be used in the liturgy of the Coptic Church to the present day.

140 *Funerary stela inscribed in Coptic, probably from the Esna region. Some of the paint still survives, showing how the plant motifs and the inscription were picked out in red. H: 45 cm. 4th–6th centuries AD.*

141 *(Bottom) part of a limestone frieze from Ashmunein, carved in characteristic Coptic style. Meandering plant motifs create roundels inside which are depicted a hare (right) and a lion eating a leaf (left). L: 75 cm, 66 cm. 4th–6th centuries AD.*

Coptic art and textiles

Coptic art shows little continuity from the art of ancient Egypt. One pharaonic survival is the *ankh* sign of life as a typically Coptic looped cross. Figurines of the goddess Isis suckling the infant Horus are often thought to have inspired the Christian Madonna and Child, but this is uncertain.

Most of the carved stonework from the monasteries dates from the 5th to 9th centuries AD. It consists of tombstones and decorated architectural fragments in limestone and sandstone (plates 140–1). Craftsmen made use of the current decorative style of the Late Roman Period. Coptic art has a tendency to purely decorative treatment, simplification and repetition. Geometric designs and plant ornamentation were popular, especially friezes with acanthus and vine-leaf scrolls inhabited by birds and animals. Coptic sculpture was originally coloured, which made up for the lack of modelling and fine detail.

Coptic textiles come from burial garments which have been preserved by the hot dry sand (plates 142–4). These clothes include tunics, cloaks, caps, belts, socks, sandals and occasionally pillow cases. Sometimes the body was wrapped in a shroud made from textile wall hangings. The colours have survived well due to the fastness of the dyes used: red from madder, yellow from berries, blue from indigo.

142 *Fragment of coloured wool and linen cloth from a burial garment. A turbanned Ethiopian (?) prince holding a sceptre is seated on a cushioned throne. Negro winged personifications of victory place wreaths upon him and negro courtiers attend him, among flowering stems at which birds peck. The winged victories suggest that an important victory is being celebrated or an important figure is being honoured. L: 20 cm. Coptic, 6th–9th centuries AD.*

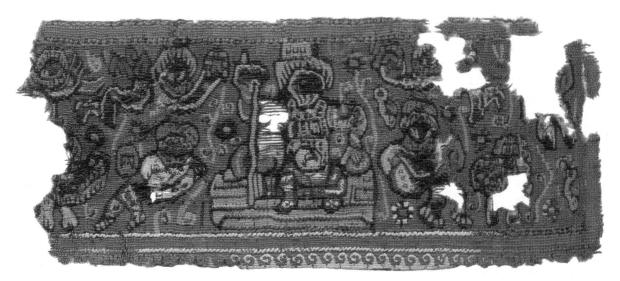

143 *(Below, left) fragment of coloured wool and linen cloth from a burial garment, decorated with a series of panels. The bottom panel has an angel or saint with a cross at the top of the head. H: 29 cm. Coptic, 5th–7th centuries AD.*

144 *(Below, right) Coptic cap, formed from several sections of silk and linen sewn together. Other head coverings were simple veils, edges of scarves, shawls, nets, headrolls and bonnets. Woollen bonnets, most likely to cover the heads and ears of children, had a cord under the chin to hold them in place. D: 23 cm. 6th–8th centuries AD.*

The basic garment was a simple tunic shape, usually of linen. It was decorated with bands, medallions and panels of wool. These were either woven into the garment itself, or made separately and sewn on. Patterns on the earliest textiles of the 4th to 6th centuries show strong Graeco-Roman influence. The motifs, in purple wool, are very similar to those on Greek vases, with geometric designs and figures from Hellenistic stories of gods and heroes. From the 5th century a greater variety of colours was used. Christian motifs emerged, such as crosses and angels, together with birds and animals, as in Coptic sculpture. The later influence of Islamic art prevented the depiction of animal or human figures, and eventually the only indication of a Christian origin was a Coptic inscription or a cross.

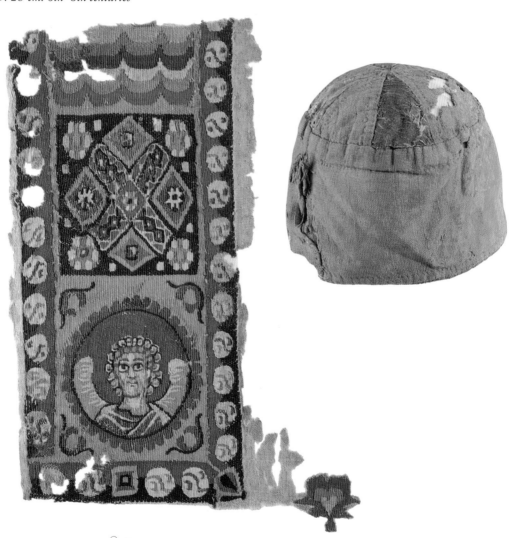

8
The Kingdom of Meroe

The Meroitic kingdom

The Meroitic civilisation flourished in the area of modern Sudan from the 6th century BC to the end of the 3rd century AD. It was in effect the inheritor of ancient Egyptian culture, especially in art and religion.

The Meroitic kingdom developed from the kingdom of Napata, which had formed the 25th Dynasty in Egypt. The capital was moved from Napata to Meroe, near the Sixth Cataract, probably in the 6th century BC. The Napatan culture had been completely Egyptian, but with the withdrawal up the Nile new African elements developed. The Meroitic kingdom proper, a stable, well-organised African state, dates from about 270 BC when the royal cemetery was moved from Napata to Meroe. Meroitic occupation stretched from Dakka in Egyptian Nubia to Sennar, far up the Blue Nile, about 1,125 kilometres as the crow flies.

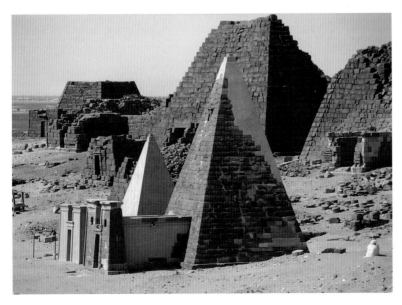

145 *Pyramids at Meroe. The Meroitic kings adopted the pyramid shape for their tombs under Egyptian influence. The Meroitic pyramids contained two or three chambers. The kings were mummified and placed in coffins with burial goods often of Egyptian type and manufacture. Each pyramid was surrounded by an enclosure wall, which also contained a chapel on the east side.*

146 *Pottery ostraca inscribed in ink in cursive Meroitic script, found near the temple of Amun at Meroe. The Meroitic language remains largely unknown, although the value of individual letters has been deciphered. H (top right): 14 cm.*

Contacts with Egypt were close throughout the period. From Egypt were sent silver and bronze ware, glass, wine, olive oil, lamps and pottery. Meroe exported to Egypt gold, iron, ivory, ostrich feathers and other African products. The majority of the Meroitic gods were very similar to Egyptian deities, but some were new. The lion god, Apedemek, a god of war, became the most important. The Meroitic hieroglyphic and cursive scripts were derived from Egyptian. They are alphabetic, using 23 symbols, and include notations for vowels. Although the script has been deciphered, the language is not understood (plate 146).

Meroe's greatest legacy was the development of ironworking, which had always been backward in Egypt. The city of Meroe itself was in an iron-rich area, and has been called the Birmingham of Africa. It was probably responsible for the beginning of the African Iron Age.

The history of Meroe

We know little of the political history of Meroe, and have fixed dates for only a few kings. Even their order is uncertain. A glimpse of the royal court is given by the Greek historian Diodorus Siculus. He tells the story of King Ergamenes, a contemporary of Ptolemy II (285–246 BC), who stopped the custom of ritually killing the king practised by the priests by massacring them first. We know that at times there were ruling queens with the title *kandake* ('queen mother'), which appears in the New Testament Acts of the Apostles 8:27 misinterpreted as a proper name, 'Candace, queen of the Ethiopians'.

Much of our information on Meroe's history comes from Classical historians, and concerns contact with the Roman empire, including Egypt. In 28 BC the Romans conquered Upper Egypt as far as Aswan. Four years later the Meroites invaded the area, defeated three Roman cohorts and plundered Aswan. The Meroites in their turn were driven out by the Roman Prefect Petronius, who advanced as far as Napata. The Roman historians Pliny and Seneca describe expeditions sent to Meroe by the Emperor Nero in the 1st century AD, one as a military reconnaisance, the other to investigate the source of the Nile.

The city of Meroe

Meroe was first identified by James Bruce (1730–1794) on a return trip from Abyssinia in 1772. The excavations of John Garstang from 1909 to 1914 were the first systematic investigation and examination on a large scale of the city and its surroundings (plates 148–9). Garstang revealed a number of temples, palaces and public buildings, including a royal enclosure.

The city of Meroe covers a large area on the east bank of the Nile. Much of it is unexcavated, including the mounds of slag and other debris of iron smelting for which Meroe was famous. The largest

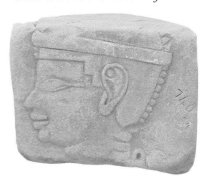

147 *Sandstone relief from Meroe, showing the head of a prince or princess wearing a headband or diadem. H: 23 cm. 1st century AD.*

148 *View of the excavations at Meroe in 1912 directed by John Garstang. The debris from the digging was removed by an overhead railway specially built for the purpose.*

149 *John Garstang and his wife inspecting typical Meroitic pottery jars at Meroe in 1911 with the Assyriologist Professor A H Sayce (1845–1933). Although Sayce was not an Egyptologist, he travelled extensively in Egypt and spent many winters on his own boat on the Nile copying inscriptions.*

single building excavated was the temple of Amun, which was approached through a small kiosk and flanked by four stone rams. The walls of a smaller temple were covered with stucco and brightly painted with scenes of a king and queen. Also within the royal enclosure was a bath, a large stone tank with a system of water channels leading into it from a well. Other major buildings were a so-called Sun Temple, a temple of Isis and a temple of the lion god, Apedemek. The non-royal cemeteries lie to the east of the town. Beyond these, standing on low hills, are the royal pyramids.

Meroitic art

The move of the royal cemetery to Meroe in about 270 BC coincided with important cultural and artistic developments. The local script gradually replaced Egyptian hieroglyphs. Meroitic art grew independent of Egyptian models and reflected a more southern influence, though it remained receptive to external influences.

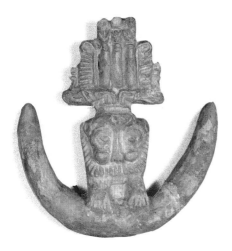

150 *Glazed terracotta figure from the Royal Baths at Meroe of the head and forepaws of a lion, probably the lion god Apedemek, wearing a crown, on a crescent moon. Crescent moons and lions' heads separately were common Meroitic decorative motifs, but they are normally found together only on vessels. H: 24.2 cm. 2nd–3rd centuries AD.*

There is no fixed style in Meroitic art, but there are recognisable characteristics, such as the broad shoulders, long necks and round heads in representations of people. Artistic forms were simplified over time, and became more abstract. Typical of Meroitic art were column bases in the form of animals, and triple protomes – rectangular blocks with sculpted human and animal heads, set into walls above temple entrances.

Stone reliefs form the largest group of Meroitic art (plates 147, 151). The greatest number come from the pyramid chapels of Meroe. All the reliefs were strongly influenced by Egyptian art and religion. The main decoration on the walls was a scene of the king on a throne with lion-shaped arm rests, protected by the goddess Isis.

151 *Sandstone relief from Meroe, showing the head, shoulders and hand of a king. Meroitic relief sculpture, found mainly on walls of temples and tomb chapels, was heavily influenced by Egypt. L: 50 cm.*

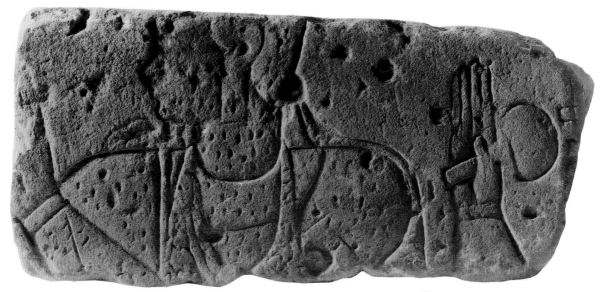

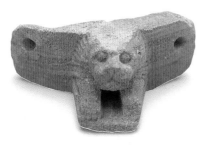

A characteristic product of the Meroitic culture is its fine wheel-made painted pottery, which is of very high quality (plates 153–4). Typical are thin-walled cups and jars painted with a mixture of Egyptian and Hellenistic motifs. The decorative use of uraei and the lotus design is common. The handmade black burnished pottery is quite different, and has incised decoration which was applied before firing. Its shapes are based on gourds or bags (see plate 149), and it was fired at a low temperature, probably in a shallow hole in the ground.

Jewellery was one of Meroe's finest products, and comes mainly from the royal tombs. It was closely modelled on contemporary Egyptian styles, but developed a specifically Meroitic character. Much of the jewellery is shown in use on the reliefs of queens. Ear-rings, bracelets and finger rings were often of gold. Common designs were Hathor-heads on ear-rings and figures of Isis on finger rings.

152 *Lion's head and forepaws carved on a small sandstone plaque. The curve of the plaque indicates that it was mounted on a round basin, with pins drawn through the circular perforations at each end. It was probably intended as a spout, with the square hole between the forepaws providing a channel for liquid. From the temple of the lion god Apedemek at Meroe. W: 8 cm. Probably 1st century BC.*

153 *Rim of a pot, from Meroe, painted with a naked couple and lotuses. The man is bearded, and the woman holds in front of her a large rectangular patterned object. This is a rare example of a narrative scene in Meroitic pottery, probably influenced by contemporary styles in Alexandria. It is likely that the scene was meant to be erotic in nature. D: 10.3 cm. Probably 2nd century AD.*

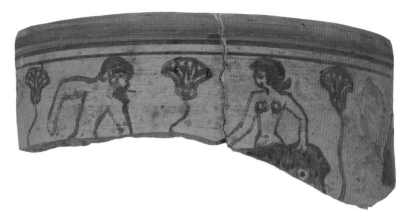

154 *Painted bowl with floral decoration. The fabric of the bowl is extremely fine and light. The technical excellence of such painted wheelmade pottery was the finest achievement of Meroitic craftsmen. The floral patterns are of Graeco-Roman origin. D: 10.6 cm. Restored, from Meroe.*

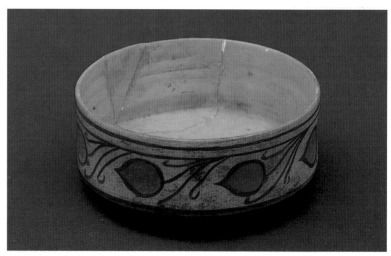

98

The end of Meroe

Meroitic civilisation peaked in the 1st century AD, and the next 300 years were a long decline. Imports ceased and the construction of monumental buildings ended. The Romans now used the trade routes through the Red Sea and Arabia, bypassing Meroe which became a backwater at the same time as Egypt was declining.

At about the end of the 3rd century AD Meroe was overrun by nomads from the west. Its fall did not cause a break in relations with Egypt. People known as the X-Group culture continued to trade with Roman Egypt and the Mediterranean in the 5th and 6th centuries. Christian missionaries reached Nubia in the 6th century. After the Arab conquest of Egypt in AD 640, Christian Nubia came under Monophysite control.

The Arabs failed twice to conquer Nubia, which prospered culturally and politically for several hundred years until disruptions brought an end to Christian rule, and the adoption of Islam by virtually all the inhabitants by the 16th century.

155 *Pottery sherd of black burnished ware in the shape of a human face, from Meroe. H: 4.5 cm.*

156 *Fragment of a millefiori glass plate from Meroe, with blue flowers on a black background. The millefiori technique originated in Egypt for making decorative inlay plaques. Coloured rods were arranged in a pattern so that they could be fused together to make a composite rod. Transverse slices cut from the composite rod each reproduce the original pattern. L: 8.8 cm.*

Appendix 1

The Liverpool Collection

'Next to the contents of the Egyptian galleries in the British Museum, the most important collection of Egyptian antiquities in England is that of the late Mr Joseph Mayer presented by him in 1867 to the Liverpool Museum.' So wrote Amelia Edwards, novelist and promoter of Egyptology, in 1888. Joseph Mayer (1803–1886), a Liverpool goldsmith and antiquarian, devoted his life and fortune to collecting material for the public good (plate 157). The collection donated to Liverpool consisted of nearly 14,000 items, including Egyptian, prehistoric, Classical, Etruscan, Peruvian and Mexican antiquities, medieval and post-medieval manuscripts, ivories, enamels, embroideries, pottery, clocks and watches, arms and armour, and ethnology.

Mayer's collection was built up at a time when the great private collections of the first half of the 19th century were being dispersed. Much of the Egyptian collection came to Mayer by purchase from Joseph Sams (1784–1860), a Darlington bookseller. Sams visited Egypt and Palestine in 1822–3, bringing back an extensive collection of antiquities. Many were acquired by the British Museum through a Parliamentary grant in 1824. Sams himself had bought items at the 1835 London sale of the collection of the late Henry Salt, formerly British Consul-General in Egypt. Between 1830 and 1839 Sams also purchased the Egyptian collection of Charles Bogaert (1791–1875) of Bruges, which included several famous pieces, such as the wood figure of a servant carrying a lotus-shaped jar (plate 74).

Mayer's Egyptian collections were enhanced from three other sources: the 1852 Sotheby sale of the collection of Viscount Valentia, and the private purchase in 1857 of the collections of the Reverend Henry Stobart and Bram Hertz.

Mayer displayed his Egyptian material in an 'Egyptian Museum' at 8 Colquitt Street, Liverpool (plate 158). It opened on 1 May 1852 and was instantly a popular success. His purpose in displaying the

157 *(Opposite) Joseph Mayer at his home in Clarence Terrace in Liverpool in about 1840, painted by William Daniels.*

158 *The Jewellery Room in Mayer's Egyptian Museum in 1852, drawn in pencil and chalk by Henry Summers.*

material was to give the citizens of Liverpool the opportunity of seeing things otherwise only available at the time in the British Museum in London. In 1867 he donated his whole collection to the Borough of Liverpool to allow free, public, daily access.

The Mayer collection is notable for its strength in objects of a high artistic quality. On its own, however, it could not claim to be representative, since all but a handful of pieces had no provenance. Liverpool Museum had received in 1861 a small collection of antiquities from William Crosfield, a soap manufacturer and sugar refiner of Warrington and Liverpool, which included items from Thebes and Saqqara. In 1873 a few objects from Tell el-Yahudiya in the Egyptian Delta were purchased from the Reverend Greville Chester, who through ill health travelled in Egypt and the Levant during the winter. Properly excavated archaeological material, though, first came through Flinders Petrie, who was allowed to bring back to England large quantities of objects. These were presented to museums in England and elsewhere in return for donations towards the excavation.

The earliest material acquired in this way by Liverpool Museum was from Petrie's first excavations for the Egypt Exploration Fund

(EEF) at the Delta sites of Tanis, in 1883, and Naukratis, in 1884–6. Liverpool Museum altogether subscribed directly to 25 excavations carried out by the EEF, the Egyptian Research Account and the British School of Archaeology in Egypt between 1883 and 1914, including Dendera, Diospolis Parva, Abydos and Deir el-Bahri.

Important collections came to the Museum from the excavations of John Garstang (1876–1956) (plate 159). Born in Blackburn, Garstang was honorary reader in Egyptian archaeology at Liverpool University 1902–7, and Professor of Methods and Practice of Archaeology 1907–41. From 1901 to 1914 he excavated every year in Egypt or Sudan and campaigned constantly to stimulate interest in archaeology in Liverpool. He was largely responsible for founding the Liverpool Institute of Archaeology in 1904 (now the School of Archaeology, Classics and Oriental Studies at Liverpool University). Material from Garstang's excavations at Beni Hasan (1902–4), Esna (1905–6) and Meroe (1909–14) is among the most important in the Museum. In the 1930s Garstang carried out his famous excavations at Jericho in Palestine and later at Mersin in Turkey, material from which is also at Liverpool Museum.

159 *John Garstang and his wife outside the dig hut at Meroe in 1912 with trophies from a hunting expedition.*

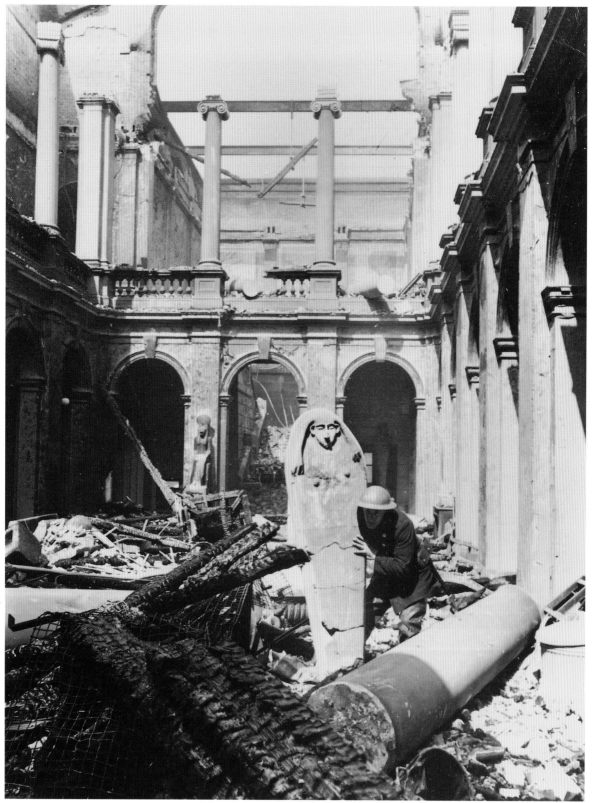

During the Second World War, Liverpool was the target of many air raids. In May 1941 a bomb fell on the Museum, which was burned out when the city water supply failed. Large parts of the collection had been removed at the outbreak of the war, but much remained on display or in store and many unique treasures were destroyed (plate 160). The remaining collections were packed away and inaccessible for the next 20 years, though collecting of new material from excavations and other museums continued. For example, in 1956 the Museum purchased almost the entire non-British collections of the Norwich Castle Museum. These included important material from the excavations undertaken in 1923–37 by the EES at Amarna, the capital of Egypt during the reign of Akhenaten. The Egyptian collection now numbers about 15,000 objects.

Since 1986, Liverpool Museum has been one of the National Museums and Galleries on Merseyside, a body that also includes the Lady Lever Art Gallery in Port Sunlight. This gallery is best known for its fine and decorative art, but its founder, William Hesketh Lever, was also interested in archaeological material. He helped to finance Garstang's excavations at Abydos in Egypt and Meroe in Sudan between 1906 and 1913, and received a share of the finds. Lever also purchased Egyptian material from dealers and salerooms, including two canopic jars which are recorded as being in France in 1719, and are thus among the earliest Egyptian antiquities to have come to Europe (plate 161).

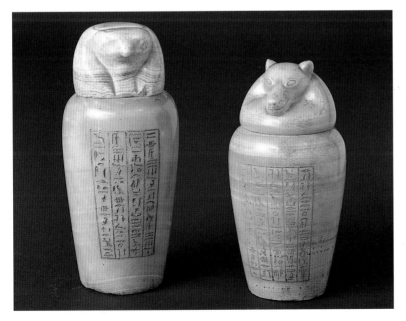

Appendix 2

List of Museum Registration Numbers

The numbers shown on the left are plate numbers for the illustrations in this book.

1 1959.148.54, 1959.148.58

2 Walker Art Gallery 2794

4 University of Liverpool Art Gallery, Sydney Jones Collection, FA 244

11 55.82.3

12 51.65.1

14 13.12.99.1

17 55.82.7

19 (*Top to bottom*) 25.11.05.39, 44.19.272, M11934, 25.11.05.40

20 (*Left to right*) 56.20.77, 1973.2.254, 56.20.42

21 (*Left to right*) 52.55.32, 52.55.31, 52.55.34, 1973.1.176, 49.47.401, 49.47.403, 1973.1.199

22 14.10.01.50

25 1966.178

26 56.22.141

27 1993.75

28 1967.35

31 51.65.2

32 24.9.00.92

34 M13825

35 (*Left to right, top to bottom*) 1978.291.309, M13626, 36.119.10a, 56.22.212, 53.109.22, M14187, 36.119.7a

37 (*Top to bottom*) 55.82.20, M13536

38 M12400

39 1978.291.264

40 13.12.05.34

41 M11186

42 M11467

43 M11396

44 (Copper) 55.82.25–31, (clay) 16.11.06.256

45 (*Top to bottom*) 4.9.07.19, 55.82.21, 1967.297

46 49.47.578

47 1978.291.325

48 M13505–6

49 (*Left to right, top to bottom*) 56.21.180, 56.21.170, 56.20.331, 56.21.181, 56.21.184, 56.21.202

50 1965.46

51 1977.109.1

52 1977.110.2

53 M11763

54 (*Left to right*) M10079, M10149, M10085

55 1967.141

56 56.21.603

57 1973.1.422

58 55.82.4

59 M11156

60 1973.1.554b

61 M11898

62 55.82.16

63 24.9.00.86

64 55.82.9

65 55.82.15

66 M11942

67 1973.2.192

68 (*Left to right*) 1973.1.127, 56.20.574, 56.54.16, 49.47.423, 49.47.414

69 56.20.255

70 M11187

71 (*Left to right*) 1973.1.124, 44.12.17, 1973.1.200, 30.86.24, 1973.1.123, 44.12.37

72 M11647

73 M13516

74 M13519

75 1977.108

76 (*Top to bottom*) M11441, M11516, 1978.291.321

77 (*Left to right*) 56.20.576–7

78 M11982

79 (*Left to right*) M11939, M11549a, M11549b

80 (*Left to right, top to bottom*) M10295, 1978.291.316, 1978.291.317, M10100

81 M11438

82 M11437

83 1966.158

84 M11809–10

85	65.231	119	M13650	142	56.21.996
86	65.232	120	1973.1.469	143	56.21.1000
87	1973.4.112	121	(*Left to right*) 61.202.158,	144	1973.3.74
88	10.9.09.1–2		M13871, M14024,	146	49.47.801
89	65.233		8.12.87.1, M13879,	147	Lady Lever Art Gallery
90	1967.210		16.11.06.320		5500
91	51.65.3	122	(*Left to right, top to bottom*)	150	49.47.847
92	M14056		M11787, M11790,	151	49.47.GN21
93	M11594		56.21.94, 56.21.92	152	47.48.212
94	M11431	123	(*Left to right*)	153	49.47.840
95	M11432		16.11.06.261,	154	47.48.207
96	1987.408		16.11.06.24,	155	49.47.905
97	M11736		16.11.06.262	156	49.47.932
98	1988.154	124	1967.60.32	157	Walker Art Gallery 7355
99	M11490	125	(*Top to bottom*) M14090,	161	(*Left to right, lids and jars*)
102	55.67		M14079		Lady Lever Art Gallery
103	17.6.20.60	126	1973.1.353		5137, 5136, 5135, 5134
104	M13997	127	M13815		
105	13.10.11.25	128	1978.291.313		
106	M14289	129	55.82.1		
107	42.18.2	130	55.82.6		
108	55.82.114	131	(*Top to bottom*)		
109	55.82.112		1973.4.135, 56.20.486b, a		
110	52.55.45	132	M13860		
111	M13864	133	M13850		
112	24.11.81.5	134	24.11.81.7		
113	1953.72	135	49.56		
114	1977.112.7	136	M11015		
115	M11014	138	M11167		
116	1993.149	139	M10035		
117	56.20.579	140	1972.290		
118	M13937	141	1966.155.1–2		

Glossary

Abydos	Town in **Upper Egypt**, where the most important necropolis of the early dynasties is located. **Osiris** became the pre-eminent god of Abydos, and his main temple was situated there.
Akhenaten	'Heretic' king of the 18th Dynasty, devotee of the sun-god **Aten**. He changed his name from Amenophis (IV) to symbolise his exclusive attachment to Aten. The name Akhenaten means 'beneficial to Aten'.
Akhetaten	'Horizon of Aten', name given by **Akhenaten** to his new capital at Amarna, midway between Cairo and **Luxor**.
Alabaster	Egyptian alabaster is a form of calcite stone, white, yellow or brown in colour, often banded. It was readily available in the eastern desert.
Amarna	*See* Akhetaten.
Amulet	Protective device or talisman, a good-luck charm in the form of objects, parts of the body or gods. Used in jewellery, popular religion and burial customs.
Amun (Amun-Re)	King of the gods during the New Kingdom. Originally a **Theban** god of wind and creative breath. He is depicted wearing a crown with two tall plumes, and his sacred animal was a ram with curved horns.
Ankh	Cross with large loop head, possibly a stylised sandal strap, the hieroglyph for the word meaning 'life'. As a sign symbolising life it is ubiquitous in ancient Egypt.
Anthropoid	Human-shaped; a word often used of **coffins** or **sarcophagi**.
Anubis	Jackal or wild dog god of the **necropolis** and of embalming.
Apedemek	Lion god of war in the **Meroitic** culture.

Assyria	The northern part of **Mesopotamia** (modern Iraq). The first Assyrian state appeared in the 18th century BC. The Assyrian empire of the 1st millennium BC conquered much of the Near East, including, for two short periods, Egypt, before falling to the Babylonian empire in 612 BC.
Atef-crown	A tall conical crown with ram's horns at the base and an ostrich feather on each side, worn by **Osiris** and occasionally kings. (See plate 43)
Aten	Manifestation of the god **Re** as the visible sun-disk. God revered by **Akhenaten**, who made Aten the supreme solar and creator god in Egypt. Aten was worshipped as a god before the reign of Akhenaten, but his supremacy did not survive the king's death.
Atum	Sun-god and creator of the universe.
Bast/Bastet	Cat-headed goddess, daughter of **Re**. Associated with the **Delta** town of Bubastis.
Bes	Popular god. Grotesque dwarf with a lion face and mane, normally depicted wearing a panther skin or a kilt. Patron of the family and protector of childbirth.
Blue Crown	Bulbous round-topped crown with flaring 'wings' at the sides, represented with dotted circles and coloured blue, a colour that indicated prestige, associated with the king in his role as a man of action, i.e. in battle or performing cult rituals in the temple. In reality it was probably made of leather sewn with metal disks.
Book of the Dead	Name given to funerary texts of the New Kingdom, developed from older collections of spells. The ancient name was 'the Book of Coming Forth by Day' containing about 200 spells, but there were other collections. The texts described the underworld and all its obstacles, and were inscribed on papyrus rolls and placed with the mummy. (See plate 39)
Byzantine	Christian empire based at Constantinople (modern Istanbul). In AD 324, the Roman Emperor Constantine, a Christian convert, founded Constantinople as the eastern counterpart to Rome. The empire was formally partitioned in AD 395 into western (Roman) and eastern (Byzantine) empires. The Byzantine empire was defeated by the Muslim tribes from Arabia, led by the Prophet Muhammad until his death, in a series of attacks from AD 630.

Canopic	Name given to the jars and boxes containing the mummified internal organs. The jars normally have lids in the shape of the four gods who protected the internal organs: **Imseti, Duamutef, Hapy** and **Qebehsenuf.** The word 'canopic' comes from the name of a Greek hero (a sailor), Canopus, said to be buried at Canopus (Abuqir) in the Delta and worshipped in Graeco-Roman times in the form of a human-headed jar. Although the 'jar' at Canopus was in the form of **Osiris** and had nothing to do with internal organs, the name has stuck. (See plates 114–15)
Cartonnage	Material formed from linen stiffened with plaster, used primarily for mummy masks and coffins.
Cartouche	Oval frame which surrounds a king's **nomen** and **prenomen.** The French word 'cartouche' means an ornamental tablet for receiving an inscription. The Egyptian cartouche depicts a loop formed by a double thickness of rope, the ends tied together.
Cataract	Area of rock outcrops in the path of a river. Between Khartoum and Aswan the Nile has six cataracts which make navigation difficult.
Coffin	Container for the mummified body, usually of wood or **cartonnage.**
Coffin Texts	Funerary texts developed in the First Intermediate Period and Middle Kingdom, found written on the insides of **coffins.** They originated in the royal **Pyramid Texts** of the 5th and 6th Dynasties, but were adapted to non-royal use, a result of the democratisation of Egyptian life following the breakdown of exclusive royal power at the end of the Old Kingdom. Their purpose was to ensure the well-being of the deceased by magical means. They developed eventually into the **Book of the Dead** of the New Kingdom.
Composite bow	A type of bow used by the New Kingdom armies, originating from the Near East. Exceptionally, it had a range of 500 m, though normally it was effective over about 175 m. It was made by gluing strips of horn and sinew to a wooden rod. Composite bows could be either triangular or recurved – consisting of two convex sections.
Coptic	Egyptian Christian church and language. The word 'Coptic' is an Arabic corruption of the Greek word *Aigyptos*, meaning 'Egyptian'.

| Cubit | Ancient measure from the elbow to the tip of the fingers, about 523 mm. The cubit was divided into seven palms or 28 digits. The cubit was most commonly used for land measurement and architecture. Some Egyptian cubit rods indicate a foot measure at the eighteenth digit, about 13¼ inches long. This is the origin of the 12-inch foot. |

| Cuneiform | Wedge-shaped script developed by **Mesopotamian** cultures. The script was impressed with a reed stylus on soft clay tablets which were then dried in the sun or baked in an oven. Cuneiform was also written on wooden boards covered with wax, especially for records of only passing value. The script was engraved on stone and metal to mark ownership or to produce a lasting monument. |

Fish (ku)	Date-palm (gišimmar)	Barley (še)	Day (ud)	Eat (kú)	Walk/stand (gin/gub)

The development of cuneiform signs from the original pictograph (top), through early cuneiform, to the classic Assyrian script of the 1st millennium BC.

| Cursive | Rapid handwriting of the **hieratic** and **demotic** scripts. |

| Deir el-Medina | Village on the west bank at **Thebes**, housing the workmen constructing the royal tombs in the **Valley of the Kings**. The village was in use for nearly 500 years, from the 18th to the 20th Dynasties. Thousands of documents, letters, literary texts and drawings found at Deir el-Medina give an intimate picture of village life. |

| Delta | Marshy area formed from the tributaries of the Nile running to the Mediterranean Sea. Area of intense agriculture, about 37,500 square km (14,500 square miles) in area. |

| Demotic | Rapid cursive form of hieratic script in use during the Graeco-Roman Period. |

| *Djed*-pillar | Stylised spinal cord, said to be that of **Osiris**. Symbol of stability/endurance. |

Double Crown	Combination of the **White Crown** of **Upper Egypt** and the **Red Crown** of **Lower Egypt**, symbolising rule over a unified Egypt.
Duamutef	Jackal god, one of the **four sons of Horus**, responsible for protecting the embalmed stomach of the deceased after it had been removed from the body during mummification.
Faience	Egyptian faience is a composite material, consisting of a body of quartz paste and a glazed surface layer. Faience objects, especially **amulets**, pendants and seals, were often formed in a mould, dried and then fired.
Faiyum	Area of land reclamation and intense agriculture south of **Memphis**, based around Lake Moeris on the west bank of the Nile.
Four Sons of Horus	Four male deities associated with the internal organs and protectors of these: **Imseti**, **Hapy**, **Duamutef** and **Qebehsenuf**.
Frit	The principal blue pigment of ancient Egypt, an artificial compound of silica, copper and calcium, also used for beads, **amulets** and other small objects. It could be powdered, mixed with water, moulded, dried and fired. It is also known as Egyptian blue.
Gesso	A plaster made of whiting and glue. Gesso was used on a large scale from the 18th Dynasty for applying to wood as a ground for painting and gilding. Later it was used for **mummy** masks and **coffins** made of **cartonnage**, which consists of layers of linen and gesso.
Gnostic	The word 'gnostic' comes from the Greek word for 'knowledge', *gnosis*. The Gnostics were an early Christian group who did not accept orthodox practices and beliefs. Gnostic texts translated into **Coptic** were found in 1945 at Nag Hammadi in **Upper Egypt**. They date to the mid-4th century AD, and are a collection of writings made by heretical monks.
Graeco-Roman	The period of **Ptolemaic** and Roman rule in Egypt, between 332 BC and AD 395.
Hapy	Baboon god, one of the **four sons of Horus**, responsible for protecting the embalmed lungs of the deceased after they had been removed during mummification.

Harpocrates	**Graeco-Roman** version of **Horus** the child, the infant suckled by **Isis**. He is normally depicted sitting on Isis' knees, occasionally sucking his fingers, and wearing the sidelock of youth, a plait of hair which grew over the right side of children's faces in ancient Egypt.
Hathor	Cow goddess, patron of women. With a human head she wears the cow's horns. She was the symbolic mother of the king, but also the goddess of sexual love, music and dance, identified with Aphrodite by the Greeks.
Hatmehyt	Fish goddess worshipped in the **Delta**.
Hatti	The ancient, indigenous name for central Anatolia (modern Turkey), the home of the **Hittites**.
Head-rest	Wooden or stone object with a semicircular head support. Used by the Egyptians instead of pillows.
Hellenistic	Something pertaining to Greek culture, following the conquests of Alexander the Great (*c.*333–323 BC).
Hes-vase	A **hieroglyph** in the shape of a tall water jar, also meaning 'praise' or 'favour', and hence often used as a shape for beads.
Hieratic	Shorthand **hieroglyphs** used for rapid handwriting. By Greek times hieratic was used only for religious texts, hence the name (from the Greek for 'priestly'), although in earlier times it was also used for literary, business and other secular documents.
Hieroglyphs	The earliest pictorial script of ancient Egypt, later used primarily for writing texts on monuments. Approximately 750 signs are known, divided into ideograms, or sense signs, and phonograms, or sound signs.
High Priest	The chief priest of each temple. Sometimes called the prophet.
Hittites	People from **Hatti** in Anatolia. There was a Hittite kingdom in the 2nd millennium BC that ruled an empire in north Syria, frequently clashing with the Egyptians. Hittite traditions continued in the so-called Neo-Hittite states in Anatolia and north Syria from *c.*1200–700 BC. These eventually came under the rule of the **Assyrians**.
Horus	Falcon god, son of **Isis** and **Osiris**. Identified with the living king and symbol of divine kingship.

Hyksos	An ancient Egyptian name meaning literally 'rulers of foreign lands'. Name given to the Asiatic kings of the 15th Dynasty, who ruled from Avaris in the **Delta**.
Imseti	God in human form, one of the **four sons of Horus**, responsible for protecting the embalmed liver of the deceased after mummification.
Inundation	Period when the Nile flooded, originally covering the whole of the surrounding plain. Today, the Aswan High Dam prevents any inundation, and provides a regular supply of water all year round.
Isis	Goddess, wife and sister of **Osiris**, called 'great of magic'. Mother of **Horus**, and symbolic mother of the king (together with **Hathor**, with whom she was often confused or identified in Egyptian mythology). In Roman times she became immensely popular outside Egypt as the centre of a mystery cult. She was also a funerary goddess, protecting the god **Imseti**.
Ka	Element of man, life force, his double, formed at birth. The tomb was known as the 'house of eternity' in which the *ka* lived forever, provided it was supplied with funerary equipment and offerings.
Karnak	Area of northern modern **Luxor**, site of the great temple of **Amun**, and the precincts of **Mut** and of Montu, the original local god of **Thebes**. An avenue bordered by **sphinxes** linked Karnak with the temple at Luxor, and canals connected the temples of Amun and Montu with the Nile. The temple of Amun was the most important temple in Egypt. It was added to and restored over a period of more than 2,000 years.
Khepri	Dung beetle or **scarab** beetle god. Form of **Re** as the rising sun. Symbol of resurrection. The dung beetle rolls balls of dung, which are its food, along the ground, and lays its eggs in similar dung balls; the Egyptians believed that in a similar way the god Khepri rolled the sun across the sky. The birth of a new scarab from the dung ball became the symbol of creation.
Kohl	Dark grey eye paint used by the Egyptians, made from galena, the sulphide of lead. The raw material was finely ground on palettes.
Lapis lazuli	Dark blue stone, often with patches or veins of white. It does not occur in Egypt, but was brought from Afghanistan. It was used in Egypt for beads, **amulets**, **scarabs** and small objects, and as inlay for jewellery. It was the most highly prized semi-precious stone in ancient Egypt.

Lector-priest	Literally 'scroll-carrier', he was an expert in sacred texts who ensured that the rites were carried out in all respects according to the strict letter of the law.
Lower Egypt	Administrative region from **Memphis** northward and all of the **Delta**, composed of 20 districts called nomes, and symbolised in the royal regalia by the **Red Crown**.
Luxor	Modern **Thebes**, on the east bank of the Nile. It was the site of a temple of **Amun**, built mainly in the reigns of Amenophis III and Ramesses II.
Ma'at	Concept of right, truth, justice, cosmic order, and the goddess personifying these. The goddess Ma'at is depicted in paintings and on figurines as a lady wearing an ostrich feather on her head. The role of the **pharaoh** was to uphold *ma'at*. In the funerary scene depicting the weighing of the heart of the deceased, his actions are weighed against the feather of the goddess Ma'at.
Manichaeism	A religion founded by the Iranian prophet Mani (216–277 AD), deliberately borrowing concepts from Christianity, Buddhism and the Zoroastrian religion of Iran. The religion spread widely throughout the Roman empire, eventually reaching southern Europe and China.
Mastaba	Name given to rectangular bench-shaped tombs, from the Arabic for 'bench'. Old Kingdom mastaba tombs consisted of a subterranean burial chamber and a rectangular superstructure with a chapel for the performing of the funerary cult.
Memphis	Ancient town south of modern Cairo. The royal residence and capital of Egypt in the Early Dynastic Period and Old Kingdom. Many later kings had a palace there, and its temples were among the most important in Egypt.
Menat	A counterpoise suspended from a bead necklace, shaken by priestesses as part of temple rituals, for instance when the cult image of a goddess was brought out of its shrine during a temple ceremony.
Menes	Legendary unifier of the Two Lands of **Upper** and **Lower Egypt**. Said to be the first king of the 1st Dynasty.
Meroe	The name of an ancient city on the east bank of the Nile in modern Sudan, between the Fifth and Sixth **Cataracts**. The Meroitic kingdom, with its capital at Meroe, flourished between the 3rd century BC and the 3rd century AD.

Mesopotamia	A Greek word which means 'in the midst of the rivers' and which is interpreted as 'the land between the two rivers', i.e., the Tigris and the Euphrates. The geographical area covered corresponds approximately to modern Iraq.
Mitanni	A confederation of Hurrian states in northern **Mesopotamia** and Syria in the second half of the 2nd millennium BC, which fought against and had diplomatic contacts with Egypt. The Hurrians were an ethnic group which may have originated in the Caucasus and Armenia, but became completely assimilated to Mesopotamian culture.
Monophysites	From the Greek *monos physis*, 'one nature', supporters of the doctrine that Jesus Christ had only a single divine nature, as opposed to the orthodox teaching that he had two natures, human as well as divine. The Monophysite doctrine was provoked by the dogmatic pronouncements of the Council of Chalcedon in AD 451, which eventually led to the schism between the orthodox **Byzantine** church and the **Coptic** and several other Eastern churches that has lasted to the present day.
Mummiform	In the shape of a **mummy**.
Mummy	Term give to artificially preserved bodies. The essence of ancient Egyptian mummification was the drying out of the body. Wrapping of the body in bandages was in order to maintain the shape of a living human being.
Mut	The principal goddess of **Thebes**. Her name comes from the word for 'mother', and like **Hathor** and **Isis** she was one of the king's symbolic mothers. She is depicted wearing a head-dress in the shape of a vulture and the **Double Crown** of **Upper** and **Lower Egypt**, but she can also be lioness-headed.
Narmer	First known king of a unified Egypt.
Natron	Naturally occurring salt used for cleansing and drying, especially in mummification.
Necropolis	'City of the dead'. A cemetery.
Neith	A creator goddess worshipped at Sais in the **Delta**. She is depicted as a lady wearing the **Red Crown** of **Lower Egypt**, or with a shield with crossed arrows. She was also a funerary goddess, protecting the god **Duamutef**.

Nekhbet	The vulture goddess of el-Kab (Nekheb) in **Upper Egypt**, and protector of the king and of **Upper Egypt**.
Nemes	Headcloth worn by the king, probably made of linen woven in a pattern of horizontal stripes.
Nephthys	Protective funerary goddess, whose name means literally 'Lady of the House/Temple'. She protected the god **Hapy**. Sister of **Osiris** and **Isis**, and wife of Seth, the god of chaos and murderer of **Osiris**.
Nomen	The name of the king before his accession to the throne, always written inside a **cartouche**.
Nubia	The Nile valley south of Aswan, now divided between Egypt and Sudan.
Nut	Sky goddess, regarded as the daughter of Shu, the air god, and Tefnut, the goddess of moisture, and the sister-wife of Geb, the earth god. She is depicted as a woman arching her body, her fingers and toes touching the four corners of the world. The Egyptians believed that the sun was swallowed by Nut as it set, passed through her body during the night, and was re-born in the morning.
Obelisk	Tall stone with battered sides and a pyramid-shaped top. Sacred to **Re**. Obelisks were often inscribed and erected by kings to commemorate an event, such as a building programme at a temple.
Official	A person in the hierarchy of administration who holds a title.
Opening of the mouth	A ceremony performed on **mummies** and statues to imbue them with life and faculties, thus enabling them to partake of the funerary offerings.
Osiris	King of the underworld and of the dead. He is depicted **mummiform**, wrapped in bandages, holding the crook and the flail, with a long beard, and the *atef*-**crown**. The dead king was identified with Osiris. The myth of Osiris, in several versions, tells of his murder by his brother Seth.
Ostraca	Flakes of limestone or pieces of broken pottery used for writing ephemeral notes and records in ink. (Singular: ostracon)
Overseer	An official who is in charge of a workforce.

Pantheon	A list of all the gods worshipped by a people, often organised in a hierarchy. No such ordered list can be produced for Egypt, since the gods, stories about gods and relationships between gods varied from place to place and at different periods.
Papyrus	Marsh plant used to manufacture a type of paper and other fibre products. It once grew abundantly in the marshy districts of **Lower Egypt**. As well as producing writing material, it was used for many other purposes: the root was eaten or used as fuel, the flowers were used as decoration, the stem was used for boat-making, the outer pith for making baskets, rope and sandals. It was also used as a medicine.
Persia	Old name for modern Iran.
Pharaoh	Name applied in modern times to ancient Egyptian kings. It derives from the term *per-aa* or 'great house', an honorific term for the king.
Phoenicia	The Greek name for the Syrian coast north of Palestine. The name meant 'dark red', because of the famous dyes of this colour produced in the region. During the Iron Age, Phoenicia was a grouping of city-states including Tyre, Sidon and Byblos, which were active in international trade and established colonies all over the Mediterranean and North Africa, particularly at Carthage.
Prenomen	The name the king took on his accession to the throne. It is always written inside a **cartouche**, and is nearly always compounded with the name of the god **Re**, for example Neb-Ma'at-Re (Amenophis III).
Pressure-flaking	A method of manufacturing flint tools, in which the flint is thinned by squeezing flakes off the surface using a wood or bone tool.
Ptah	A creator god worshipped at **Memphis**. He is depicted as a man wearing a tight-fitting skull cap. He was also the patron god of craftsmen.
Ptah-Sokar-Osiris	A funerary god, an amalgamation of **Ptah** with Sokar, a hawk god who was regarded as a manifestation of **Osiris**. Wooden figures of Ptah-Sokar-Osiris sometimes contained the **papyri** on which the **Book of the Dead** was written.

Ptolemaic	The Ptolemaic Period dates from 332 to 30 BC, between Alexander the Great's conquest of Egypt and its becoming a Roman province. Following Alexander's death, his empire was divided among his generals. Ptolemy acquired Egypt and established the Ptolemaic dynasty, proclaiming himself king as Ptolemy I Soter in 304 BC.
Punt	Area in Africa, possibly Somalia. It appears in Egyptian texts as the source of exotic products such as aromatic spices and ebony. The people of Punt also traded in gold and ivory. The expedition sent to Punt by Queen Hatshepsut is recorded on the walls of her temple at Deir el-Bahri in **Thebes**, and is the most detailed source of information on Punt.
Pyramid Texts	Funerary texts written on the walls of royal pyramids in the 5th and 6th Dynasties. These were spells to ensure the king's divinity in the afterlife.
Pyramidion	Capping stone for pyramids, or a smaller stela made in that shape.
Qebehsenuf	Hawk god, one of the **four sons of Horus**, responsible for protecting the embalmed intestines of the deceased after mummification.
Re	Creator sun-god, worshipped at Heliopolis. Many other gods were identified with Re to enhance their divinity, for example **Amun-Re**, **Re-Harakhte**.
Re-Harakhte	The form of the god **Horus** as a sun-god. The name Harakhte means 'Horus of the horizon'.
Red Crown	The Red Crown symbolised rule over **Lower Egypt**, and was a flat-topped cap with front spiral and rear projection upward. Combined with the **White Crown** of **Upper Egypt** it formed the **Double Crown**, symbolising rule over a unified Upper and Lower Egypt.
Relief	Carved stone scenes, either sunk or raised, used on tomb and temple walls, **stelae** and statues. Most reliefs in ancient Egypt would originally have been painted.
Saite	A name for the period of the 26th Dynasty, which came from Sais in the **Delta**.
Saqqara	Ancient burial site south of Cairo, essentially the **necropolis** of **Memphis**. It was used for the royal **mastaba** tombs of the 1st and 2nd Dynasties, for the Step Pyramid of Zoser of the 3rd Dynasty and for 14 other royal pyramids of the Old and Middle Kingdoms, and for private tombs of all periods.

119

Sarcophagus	Name usually applied to the stone outer **coffin**. The word comes from the Greek *sarkophagos* which means 'flesh-eater'. The ancient Egyptian term was *neb ankh*, meaning 'lord of life'. Ancient Egyptian sarcophagi were of two types, rectangular and **mummiform**.
Scarab	Dung beetle sacred to **Khepri**, symbol of resurrection. Small objects made in this shape of faience and various stones were among the most popular of Egyptian amulets. They were often inscribed on the base and could be used as seals to mark ownership.

Left to right: scarab beetle, side view of scarab amulet, top view of scarab amulet.

Sekhmet	Lioness-headed goddess of war. Wife of **Ptah**, daughter of **Re**. The name Sekhmet means 'the powerful'. Hundreds of statues of Sekhmet were set up in the reign of Amenophis III at **Karnak**. Egyptian kings regarded Sekhmet as a symbol of royal heroism and savagery in battle. She was also a healing goddess.
Senet	Ancient board game like draughts, played on a board of 30 squares.
Serapis	A god created in the **Ptolemaic** period, combining **Osiris**, Apis (the sacred bull of **Memphis**), Zeus and other Greek gods.
Serdab	Small, enclosed room in the tomb chapel, containing statues. The *serdab* had one or more slits in the wall for the statues to 'see' out and receive the offerings.
Serket	Scorpion goddess, depicted as a lady with a scorpion ready to sting on her head. She was a funerary goddess, protecting the god **Qebehsenuf**.
Sphinx	Creature with a lion's body and a human head, usually that of the king. Sphinxes are often found lining routes to temples as a form of protection and as a way for the king to identify himself with powerful gods.

Steatite	Soft stone, soapstone, usually white or grey, easily carved. Used as a base for **faience** glaze, often for **scarabs**, beads and small objects.
Stela	Tombstone or commemorative stone, either rectangular or round-topped. Carved with the name and titles of the owner, or with some text commemorating an event and proclaiming the glory of the king, and usually a scene in **relief**.
Thebes	City in **Upper Egypt**, during the New Kingdom the capital of all Egypt. On the east bank are the temple complexes of **Luxor** and **Karnak**. On the west bank are royal funerary temples, the **Valleys of the Kings** and **Queens**, and the private cemeteries.
Thoth	Ibis-headed moon god, scribe of the gods and symbol of wisdom. In funerary scenes and texts, he records the souls entering the underworld and writes down the result of the weighing of the heart of the deceased against the feather of Truth (*ma'at*). His major cult centre was at Ashmunein (Hermopolis). He could also be depicted as a baboon.
Unguent	Perfumed wax or ointment, often used for anointing the body after mummification.
Unification	The joining in one kingdom of the Two Lands of **Upper** and **Lower Egypt**. This event at the beginning of the 1st Dynasty marks the start of pharaonic history. The reunification of Egypt after the First and Second Intermediate Periods was also regarded as a historical and symbolic event on a par with the original unification.
Upper Egypt	Administrative region from just south of **Memphis** to Aswan, composed of 22 districts called nomes, and symbolised in the royal regalia by the **White Crown**.
Uraeus	Rampant cobra. Symbol of kingship worn on royal crowns. Personified as the goddess **Wadjet**, protector of the king and of **Lower Egypt**, worshipped at Buto in the **Delta**. The name Wadjet means 'the green one', from the colour of the snake and the Delta's papyrus swamps.
Ushabti	Small **mummiform** servant statue placed in the tomb to do work in the afterlife. They first appeared in the Middle Kingdom.
Valley of the Kings	Secluded valley on the west bank of the Nile at **Thebes**, used for the burial of kings during the New Kingdom, from Tuthmosis I to Ramesses XI.

Valley of the Queens	The southernmost cemetery on the west bank of the Nile at **Thebes**, used for the burial of queens and royal children in the 19th and 20th Dynasties.
Vellum	Writing material made from the skins of calves and kids. Used very late in ancient Egyptian history.
Vizier	Highest official in the administration, who received his instructions from the king, and kept the king informed on all matters.
Wadjet	*See* Uraeus.

Wedjat
The eye of **Horus**. Horus' eye, restored by **Thoth** after being injured by Seth while avenging **Osiris**, became a symbol of completeness and perfection known as the *wedjat*. It is depicted as a human eye with cosmetic lines, and the markings of a falcon's cheek below. The *wedjat* became a popular protective **amulet**.

Wepwawet
Wolf god, whose name means 'opener of the ways'. He was connected with the king as a conqueror.

White Crown
Tall bulbous crown, symbolising rule over **Upper Egypt**. Combined with the **Red Crown** of **Lower Egypt**, it became the **Double Crown** of a unified Upper and Lower Egypt.

Zodiac
The association of certain constellations of stars with the months of the year, first devised by the **Babylonians**. The signs of the zodiac were not used in Egyptian astronomy until **Ptolemaic** and Roman times, when they were sometimes represented on the ceilings of temples and the lids of **coffins**.

Further Reading

Adams, B, *Egyptian Mummies*, Shire Egyptology, 1984.

Adams, B, *Predynastic Egypt*, Shire Egyptology, 1988.

Andrews, C, *Ancient Egyptian Jewellery*, British Museum Press, 1990.

Baines, J and Malek, J, *Atlas of Ancient Egypt*, Phaidon, 1980.

Bienkowski, P and Southworth, E, *Egyptian Antiquities in the Liverpool Museum I: A List of the Provenanced Objects*, Aris and Phillips, 1986.

Clayton, P A, *The Rediscovery of Ancient Egypt: Artists and Travellers in the 19th Century*, Thames and Hudson, 1982.

Davies, W V, *Egyptian Hieroglyphs*, British Museum Press, 1987.

Gardiner, A, *Egypt of the Pharaohs*, Oxford University Press, 1961 reprinted 1979.

Gray, P H K and Slow, D, *Egyptian Mummies in the City of Liverpool Museums*, Liverpool Bulletin Museums Number, Volume 15, 1968.

Hall, R, *Egyptian Textiles*, Shire Egyptology, 1986.

Hart, G, *A Dictionary of Egyptian Gods and Goddesses*, Routledge and Kegan Paul, 1986.

Hope, C, *Egyptian Pottery*, Shire Egyptology, 1987.

James, T G H, *An Introduction to Ancient Egypt*, British Museum Press, 1979.

James, T G H and Davies, W V, *Egyptian Sculpture*, British Museum Press, 1983.

Kemp, B, *Ancient Egypt: Anatomy of a Civilisation*, Routledge, 1989.

Lichtheim, M, *Ancient Egyptian Literature* (3 volumes), University of California Press, 1973, 1976, 1980.

Robins, G, *Egyptian Painting and Relief*, Shire Egyptology, 1986.

Scheel, B, *Egyptian Metalworking and Tools*, Shire Egyptology, 1989.

Seagroatt, M, *Coptic Weaves*, Liverpool Museum, 1980.

Shinnie, P L, *Meroe: A Civilisation of the Sudan*, Thames and Hudson, 1967.

Shore, A F, 'The Egyptian Collection' in *Joseph Mayer of Liverpool 1803–1886*, M Gibson and S M Wright (eds), Society of Antiquaries of London (1988), pp. 45–70.

Spencer, A J, *Death in Ancient Egypt*, Penguin Books, 1982.

Stead, M, *Egyptian Life*, British Museum Press, 1986.

Stevenson-Smith, W, *The Art and Architecture of Ancient Egypt*, Penguin Books, 2nd edition 1981.

Taylor, J H, *Egyptian Coffins*, Shire Egyptology, 1989.

Taylor, J H, *Egypt and Nubia*, British Museum Press, 1991.

Thomas, A P, *Egyptian Gods and Myths*, Shire Egyptology, 1986.

Thomas, A P, *Akhenaten's Egypt*, Shire Egyptology, 1988.

Thomas, A P, 'Lever as a Collector of Archaeology and as a Sponsor of Archaeological Excavations' in *Art and Business in Edwardian England: The Making of the Lady Lever Art Gallery*, E Morris (ed.), *Journal of the History of Collections* 4:2 (1992), pp. 267–71.

Tooley, A M J, *Egyptian Models and Scenes*, Shire Egyptology, 1995.

Watterson, B, *Coptic Egypt*, Scottish Academic Press, 1988.

Watterson, B, *Introducing Egyptian Hieroglyphs*, Scottish Academic Press, 2nd edition 1993.

Index

Page references in *italic* are to information given in the captions. **Bold** refers to the subjects of illustrations and to glossary definitions. References to the main text and to information in the glossary are in roman.